Then&Now

# CHERRY HILL

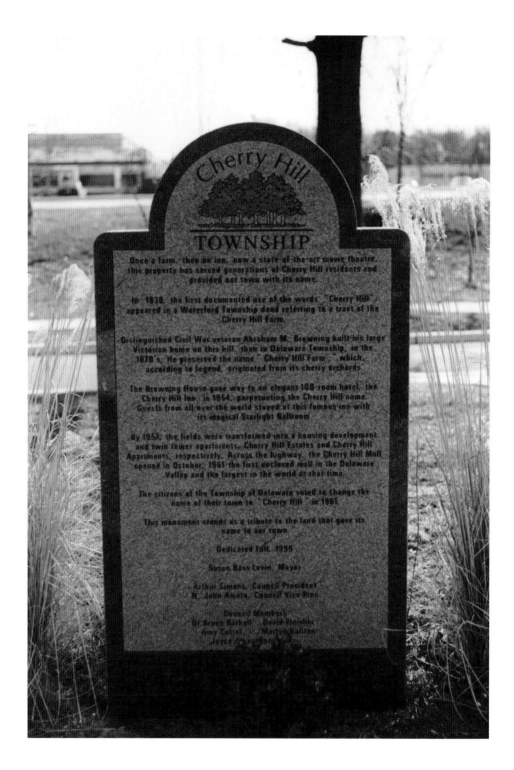

This monument, which was erected by Cherry Hill Township officials and members of the Cherry Hill Historical Commission in 1999, is situated at the foot of the driveway to the Loews movie theater on Route 38 at Haddonfield Road. The monument tells the story of the significance of the property to the township's history.

# Then & Now
# CHERRY HILL

Mike Mathis

ARCADIA

First printed in 2001.

Published by Arcadia Publishing,
an imprint of Tempus Publishing, Inc.
2A Cumberland Street
Charleston, SC 29401

Printed in Great Britain.

Library of Congress Catalog Card Number: 2001091213

For all general information contact Arcadia Publishing at:
Telephone 843-853-2070
Fax 843-853-0044
E-Mail sales@arcadiapublishing.com

For customer service and orders:
Toll-Free 1-888-313-2665

Visit us on the internet at http://www.arcadiapublishing.com

*I dedicate this book to my wife, Beverly, and to
my children, Melissa and Michael.*

# CONTENTS

# ACKNOWLEDGMENTS

The following people were extremely helpful in helping me locate photographs and providing information: Oscar and Jean Hillman, David Lummis, John O'Brien, Peter Hamilton, Marie Sergi, Jacqueline Gallombardo, Gordon DeCou, Richard Goodwin, Jennie Swiderski, Eva Gilmour, Howard and Mamie Buehler, Nancy Barclay, Alice and Derben Garwood, Lori Bixler, Max Odlen, Harold Sarshik, Alan Black, Steve Surovick, Marge Della Vecchia, Rachelle Omenson, Lou Montana, Alan Finkelstein, John Seitter of the Camden County Historical Society, Doug Winterich of the Burlington County Historical Society, Capt. Michael Morgan of the Cherry Hill Police Department, Gary McDowell of the Cherry Hill Emergency Medical Services, Bob Georgio of the Cherry Hill Fire Department, Joseph Diemer and the staff of the Delaware River Port Authority, Tom Burke of International Thoroughbred Breeders, Sally Callaghan of the Friends of the Barclay Farmstead, Denise Weinberg of the Cherry Hill Historical Commission, Barbara Shapiro of the Cherry Hill Public Library (director), and Frank Bryson of the Cherry Hill Township Department of Public Works.

# INTRODUCTION

The landscape of Cherry Hill today is not much different from how it appeared 30 years ago. Shopping centers and tract housing developments dominated the landscape, and a handful of farmers continued to work the land like their predecessors had less than a generation before.

Just 20 years earlier, in 1951, Delaware Township (as Cherry Hill was known from 1844 until 1961) was a largely agrarian town with a handful of businesses and residential neighborhoods, such as Colwick, Erlton, Hinchman, Woodland, Barlow, and East Merchantville. The township was considered a distant locale since it was just beyond the inner-ring suburbs outside Camden.

As early as the 1940s, however, township officials realized how attractive their town was to potential developers. "Situated as we are, adjacent to a metropolitan area with two main highways, we have, literally, acres of diamonds," Delaware Township committeeman Harry L. Cranmer commented in April 1942. It was not long before tens of thousands of people would help that prophesy come true.

Three months after Cranmer's pronouncement, Vineland businessman Eugene Mori opened Garden State Park, which would become the catalyst for the explosive development that would turn the township (renamed Cherry Hill by voters in 1961) from 24 square miles of farms and orchards into one of the nation's premier entertainment destinations in the 1950s and 1960s.

The Latin Casino, the Rickshaw Inn, the Rustic Inn, Cinelli's, the Hawaiian Cottage, and the Cherry Hill Inn were among the most popular nightspots. Meanwhile, the new families who moved to the area enjoyed ice cream on hot summer nights at Richman's, DeCou's Dairy Bar, or at the Cowtail Bar, the latter operated by Mayor John Gilmour and his wife, Eva.

New housing developments sprouted on former corn and soybean fields with names like Kingston Estates, Cherry Hill Estates, Barclay Farm, Windsor Park, Woodcrest, Downs Farm, and Brookfield, causing the population to surge from about 5,000 in 1950 to more than 60,000 just 20 years later.

Today, the buzzword in Cherry Hill is redevelopment. All of the old nightclubs on the west side of town are gone, replaced with chain-style eateries and office buildings. The Cherry Hill Inn is now the site of a 24-screen movie theater, and Garden State Park is scheduled to close permanently by the end of 2001, paving the way for construction of a combination residential-commercial-office development.

Meanwhile, new residents continue to move into new homes in developments such as Buttonwood Estates, Springdale Crossing, Short Hills Farm, Europa, and Bishops View, helping push the population to nearly 70,000 in the 2000 census.

The mid-to-late 1950s marked the era when huge tracts of farmland in Delaware Township were transformed into modern housing developments and the township as we know it today began to take shape. Pictured here in early 1957 is the Brookfield development, which was constructed on Haddonfield-Berlin Road just west of the New Jersey Turnpike. An old farmhouse and barn are on the left, virtually surrounded by split-level and Cape Cod–style homes. The house burned down in June 1958. The last two streets in Brookfield, East Valleybrook and Ashbrook Roads, would be constructed on the fields at the bottom of the photograph.

# Chapter 1
# COUNTRY ROADS

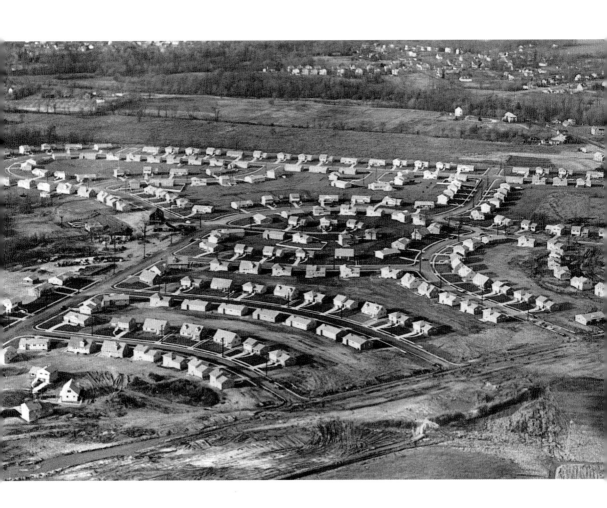

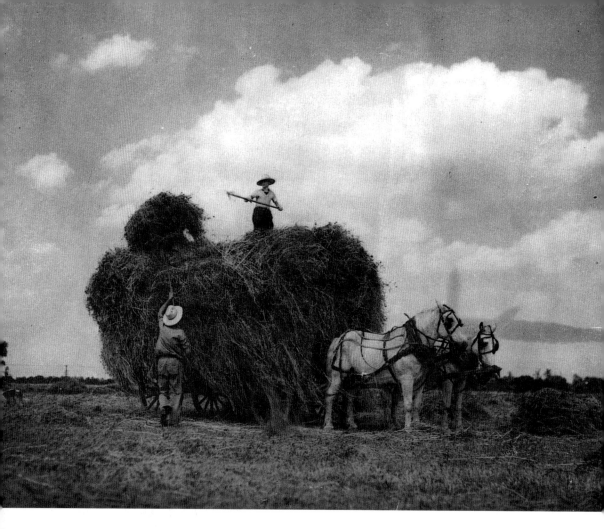

Before the Cherry Hill Mall was built in the early 1960s, the property was the site of the George Jaus Farm. Above, two men load a horse-drawn wagon with hay.

The Aaron L. Thomas house was a fixture on Whiskey Road (now Chapel Avenue) in the Woodland section long before other homes were constructed in the area. Thomas purchased 37 acres of land off Whiskey Road in 1899 and gave the house number 1179—the same house number the family had on Haddon Avenue in Camden. Beechwood, Hollywood, and Northwood Avenues were cut through the Thomas property, on which the Woodland firehouse was built. Thomas died in 1922.

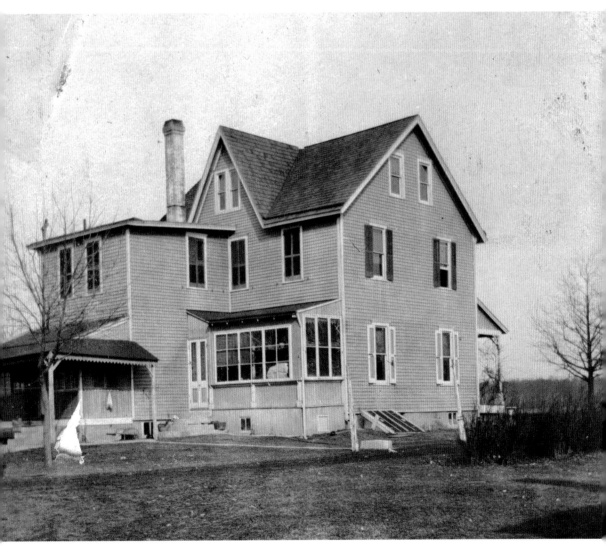

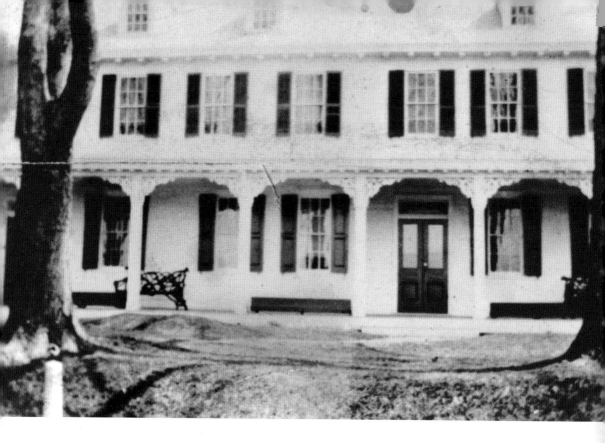

This house on Chapel Avenue was owned by Joseph Hinchman, a landowner and Delaware Township official who donated the land on which the former Hinchman School was located. The Hinchman section of the township also bears his name.

The Ellis House on Kings Highway between Belle Arbor Road and Chapel Avenue is believed to have been built *c.* 1725, making it the oldest house in Cherry Hill. The property's history dates to 1691, when records indicate Simeon Ellis purchased the land from Francis Collins. William Ellis, a local carpenter, inherited the 233-acre site in 1715, and his three daughters inherited it in 1759. Rumors say the house is haunted; sounds such as whistling, footsteps, and a child's laughter have been reported. The Ellis's slaves were buried in a site just east of the house.

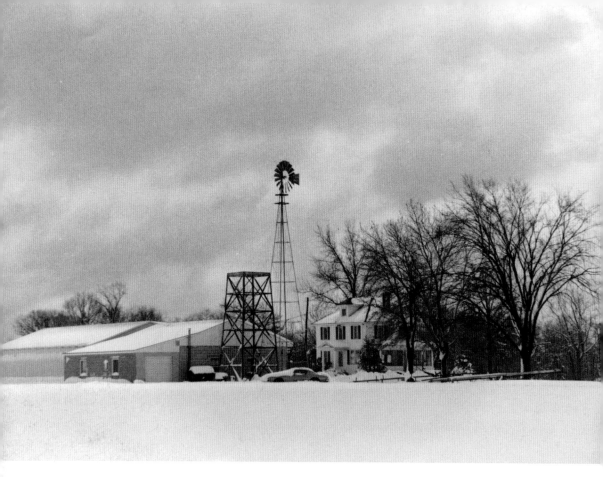

This farmhouse stood in the center of the Sergi farm, which was located between Springdale and Marlkress Roads. Joseph and Dominic Sergi operated the 250-acre corn and vegetable farm from 1942 until 1985. In the 1980s, the farm comprised about a quarter of the undeveloped, privately owned land in Cherry Hill. Townhouses and single-family homes now occupy most of the property.

John Wilkins built the Short Hills farmhouse on Evesham Road in 1860. It was once the home of Sen. David Baird—a powerful Camden County Republican leader whose power spanned from 1880 to 1933. Short Hills was a well-known horse-training facility before homes were built on the property in the late 1990s. In 2001, the house was home to the Olive restaurant.

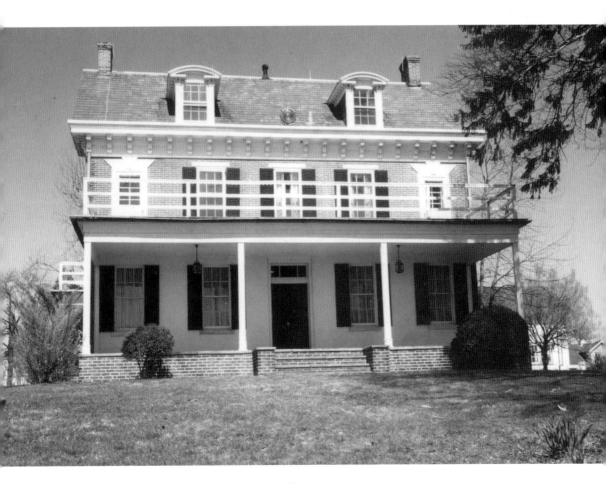

This was the home of Bud and Louise Tomlinson, longtime Delaware Township–Cherry Hill residents who lived in the Ellisburg area. Today, the house is home to a bridal shop.

Bud's Market was one of many small produce stands that dominated the rural landscape in Delaware Township–Cherry Hill through the 1960s.

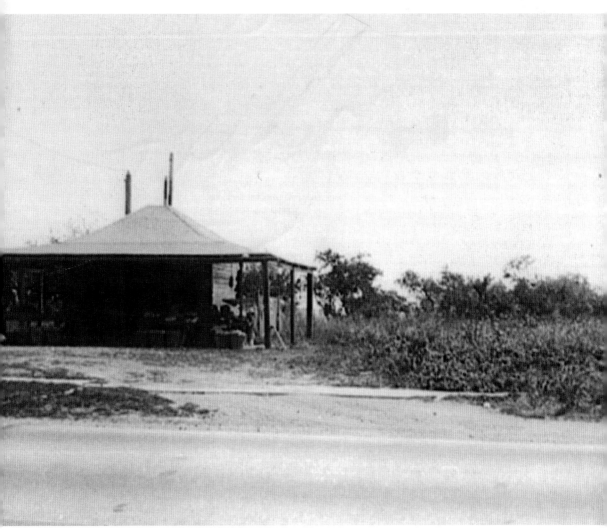

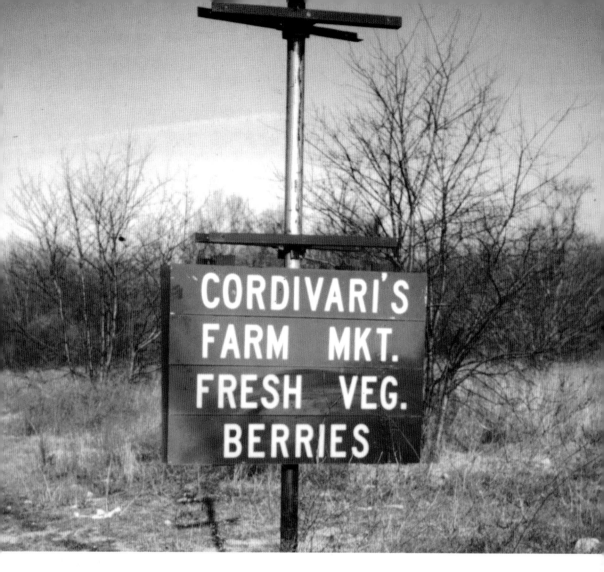

Cordivari's Farm Market was one of numerous markets and roadside stands that sold fresh Jersey-grown produce to the residents of more populated areas. The market was located on what is now the Saw Mill Plaza shopping center on Route 70.

The barn below was located on the Alexander Cooper property, which comprised much of what is now the Woodcrest Country Club. Cooper, a farmer in Delaware Township, served on the Delware Township Committee from 1844 (when Delaware Township was created from Waterford Township) to 1849. The barn, which was built in 1888, stood on the property until the early 1960s. (Courtesy Camden County Historical Society.)

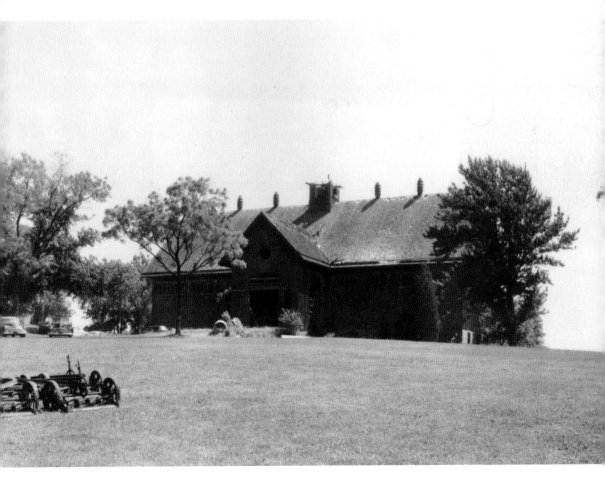

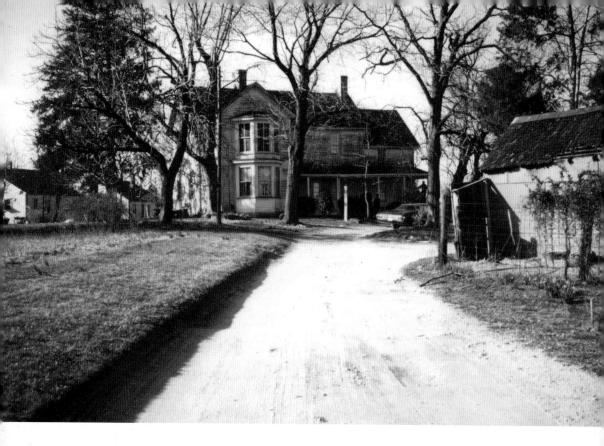

The Anderson farmhouse, also referred to as the Hillman-Stiles House, was built on Evesham Road near the Ashland section of the township and the border with Lawnside in the 1700s. Many additions were made to the home during the 19th century. The home is a private residence today.

The Butts House on Evesham Road, near the township's boundary with Evesham, was built in the 18th century. It was believed to have first belonged to the Matlack family, and a mill had been located nearby at one time. Records indicate the mill was located on a tributary of the north branch of the Cooper Creek and was known as Sparks' (or Hopkins') Gristmill. The property is now the site of the M'Kor Shalom synagogue.

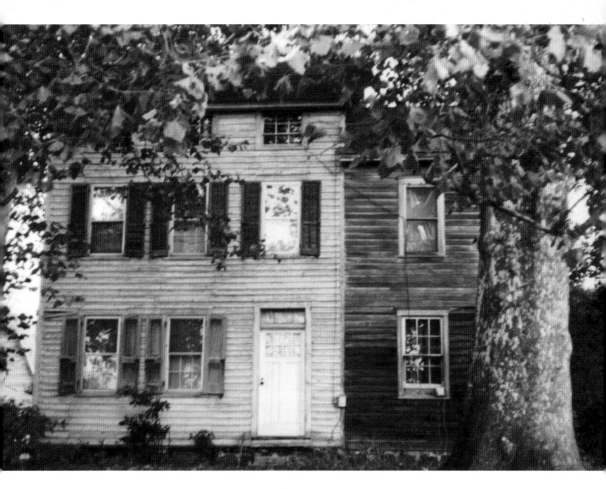

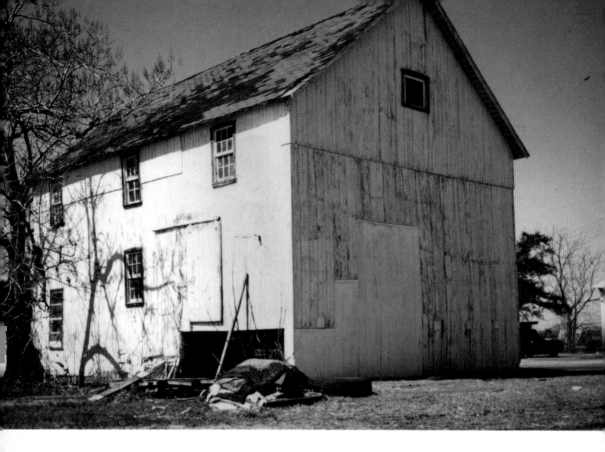

This barn was located on the Dobbs Farm, which was located on Haddonfield-Berlin Road near Interstate 295. The property is now occupied by Comcast, but the Dobbs name is perpetuated in the street that connects the Comcast building and other buildings behind it to Haddonfield-Berlin Road.

The Roberts House on Haddonfield–Berlin Road was built between 1810 and 1820. The home, which also was known as Ice House Mansion, was named for Dick Roberts, who purchased the forlorn house and adjacent 25 acres in 1936 while employed at RCA in Camden. Roberts sold the property in 1975, and the house was torn down to build the Uxbridge condominium development.

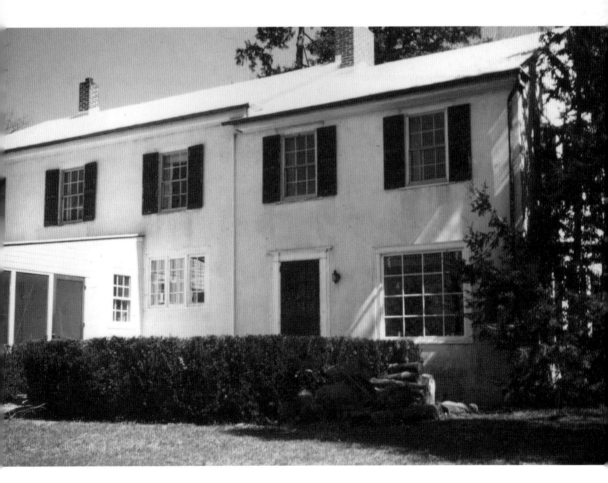

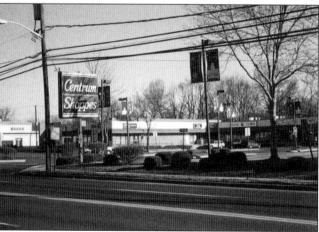

The Brennan House on Haddonfield–Berlin Road was built in the 1780s and was a fixture for generations in the Batesville area. The house was torn down, and the property is now the site of the Centrum Shoppes shopping center.

These two homes still stand on Kresson Road in Batesville. Batesville developed around the busy junction of Haddonfield-Berlin and Kresson Roads and was named for William Bates, an early settler, property owner, and developer in the 1800s. Batesville featured a blacksmith, a wheelwright, and other stores.

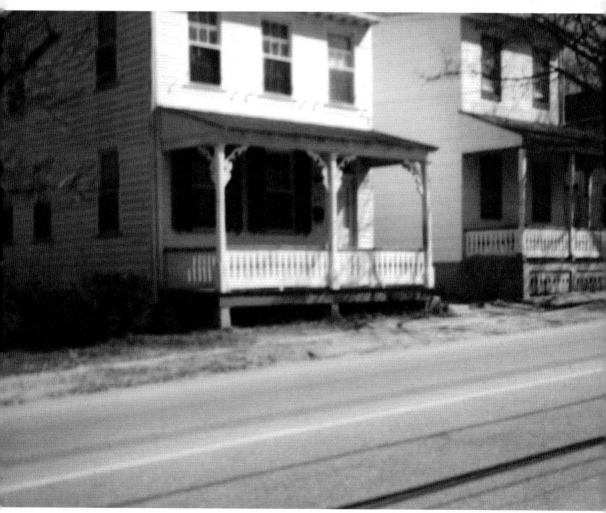

The Ellis House at Kresson and Cropwell Roads was one of many farmhouses that dominated the rural landscape prior to the 1960s. The house was torn down and is now the site of the Frenchman's Pointe development.

The Danner House on Browning Lane was built in the 1700s on land that is now occupied by the Centura condominium development.

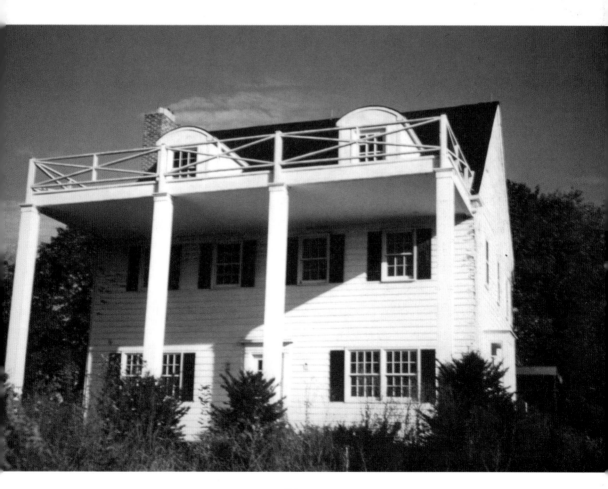

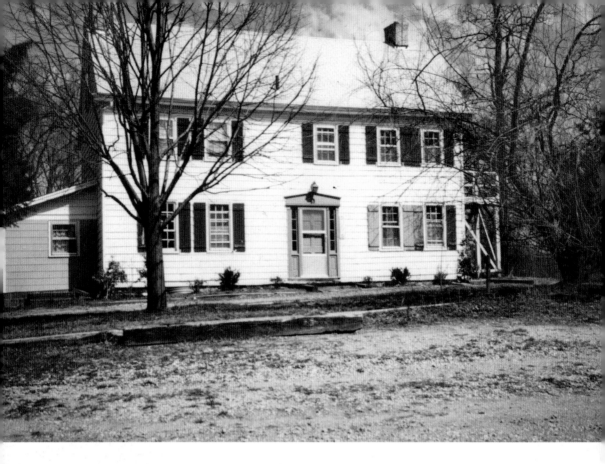

The Pebble Creek House on Marlkress Road was built in the 18th century and was added onto in the 19th century. A nursery business known as the Pebble Creek Nursery was operated here by Bill Lummis from the late 1950s until his death in 1967. The house has been torn down and a commercial building now occupies the site.

The Gravener House on Kresson Road is now the location of LaCampagne, one of the best-known French restaurants in the Philadelphia area.

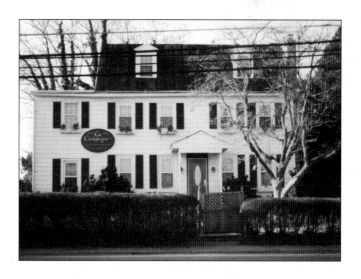

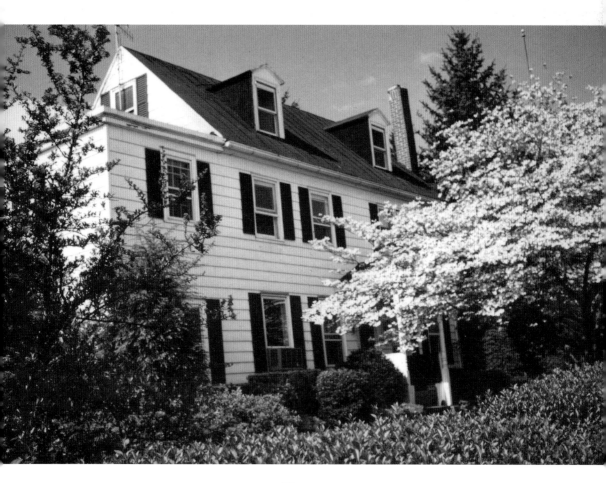

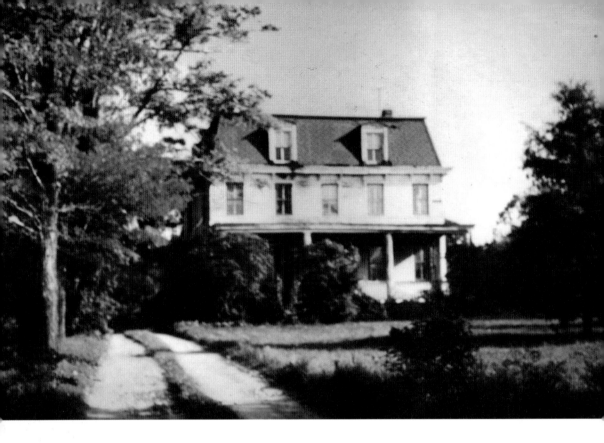

The Headacre farmhouse on Kresson Road, near Springdale Road, was known for its kennels, which were located for years on the property. The house has been demolished and the property has become Buttonwood Estates, an upscale housing development.

The barn below was part of the Griscom property, which encompassed most of what is today the Surrey Place East development. One of the roads in the neighborhood is Longstone Road. A member of the Lippincott family built the Griscom House in 1840. It is no longer standing.

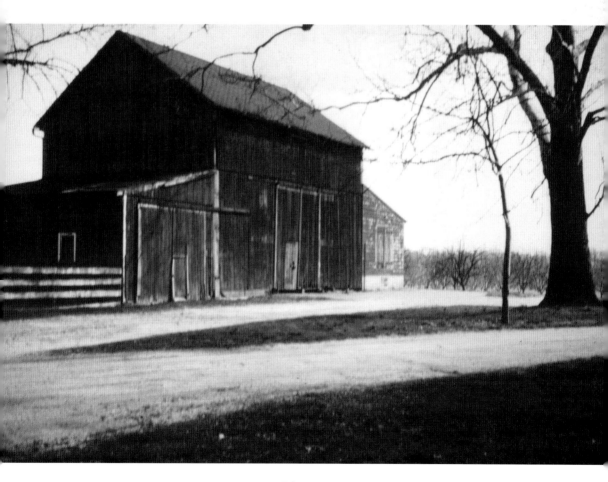

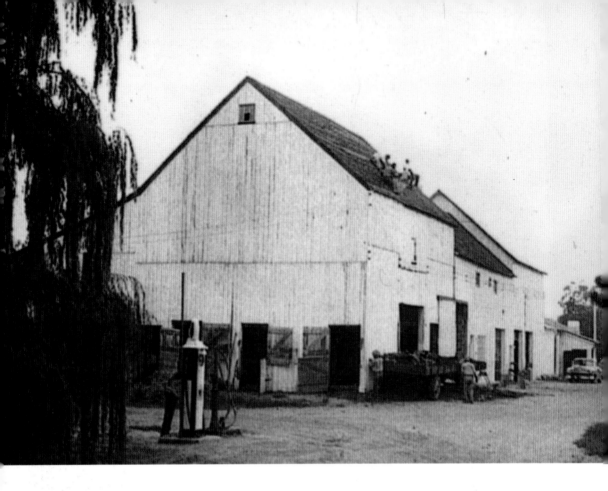

The Barton Farm was located on Kresson Road near what is now Heartwood Drive in the Willowdale development. Lewis W. Barton's father and uncle were among the area's first commercial fruit growers, starting in the peach business in 1910. The operation consisted of the 360 acres on Kresson Road and about 300 acres on Greentree Road on land that is now the Point of Woods development.

The Barclay Farmstead dates to the early 1800s and was built by Joseph Thorn, who purchased the property in 1816. The 32-acre site, which is situated on Barclay Lane in the Barclay Farm section of Cherry Hill, was acquired by the township in 1974 and is listed on the State and National Registers of Historic Places. The Barclay family last occupied the house in 1929.

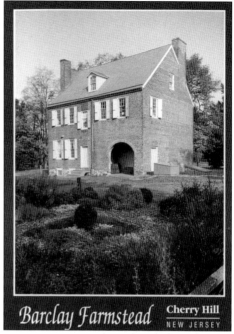

Barclay Farmstead    Cherry Hill
                     NEW JERSEY

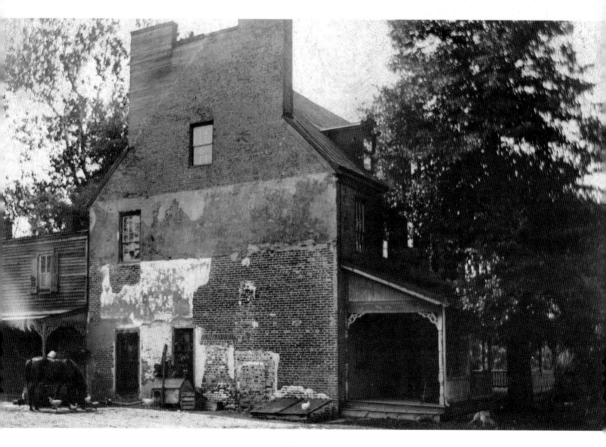

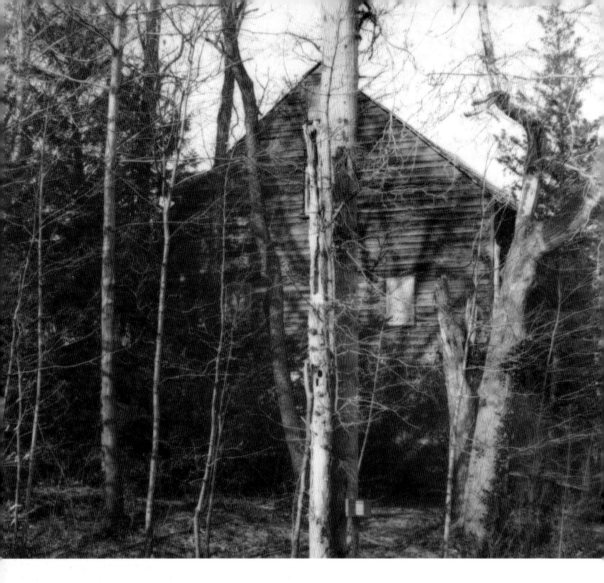

Leconey's Gristmill was built *c.* 1838 on what is now the area where Route 38 crosses a tributary of the south branch of the Pennsauken Creek near the township's border with Maple Shade. The property was then passed to Richard Leconey, who died in 1889, and was later operated by Thomas Andrews. At one time, the machinery was removed and the mill was used as a tearoom. It is now the site of the Woodland Falls Corporate Park.

Below is the farmhouse for the property on which the St. Peter Celestine Catholic Church was constructed on Kings Highway. The parish was created in 1961 and comprised parts of Christ the King in Haddonfield, St. Peter's in Merchantville, and Queen of Heaven in Cherry Hill. Mass was first celebrated in the auditorium of Cherry Hill High School West and in Kingston Elementary School. The parish school opened in September 1962, and the church was erected in 1967.

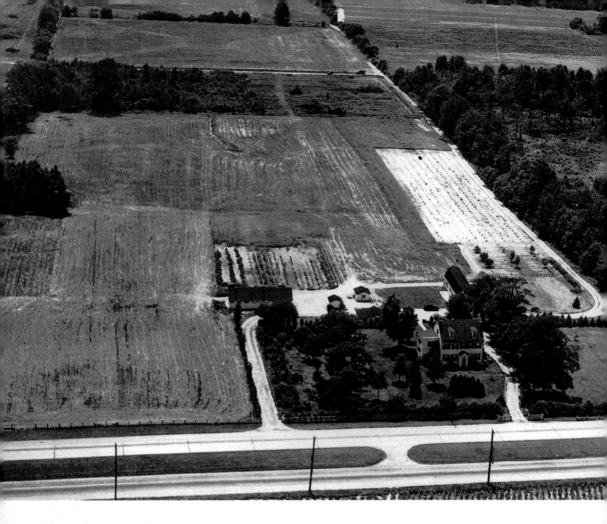

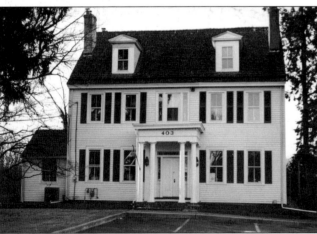

The Saltzman House on Marlton Pike (Route 70), near Saw Mill Drive, has long been a part of the landscape along Marlton Pike. The house is now used as an office, and the farm behind it is now part of the Barclay Farm development.

Below, Jean and Oscar Hillman sit on a tractor parked across from a house on Evesham Road in the 1940s. The house was constructed from a kit marketed by Sears Roebuck & Company, which sold the kits in its catalogue through much of the first half of the 20th century. The house is still standing near the Sleepy Hollow development.

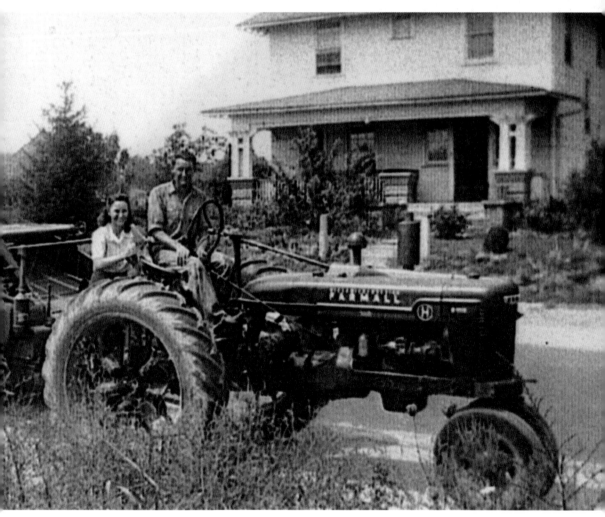

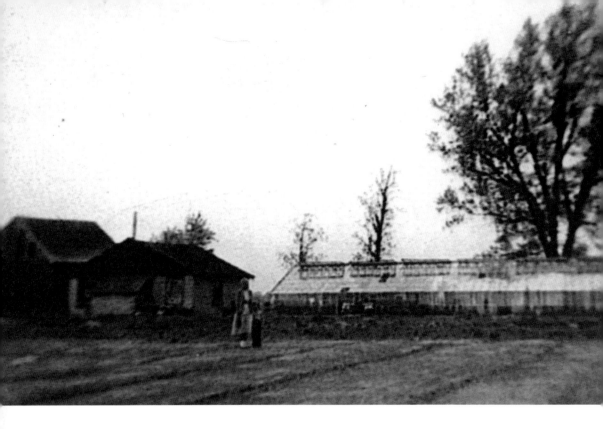

These greenhouses were located on the Hillman farm, which was located on Haddonfield-Berlin Road near the township's border with Voorhees. Oscar Hillman's father started the Hillman Bus Company in the early 1920s and farmed produce, which was sold to Campbell's Soup Company in Camden. The farm was sold off in the 1950s and much of the property became the Apple Hill development.

The Hillman Baptist Church on Kresson Road dates to 1891 and was a mission of the First Baptist Church of Haddonfield. It primarily served an integrated congregation of farmers and workers. The church has been transformed into a private residence.

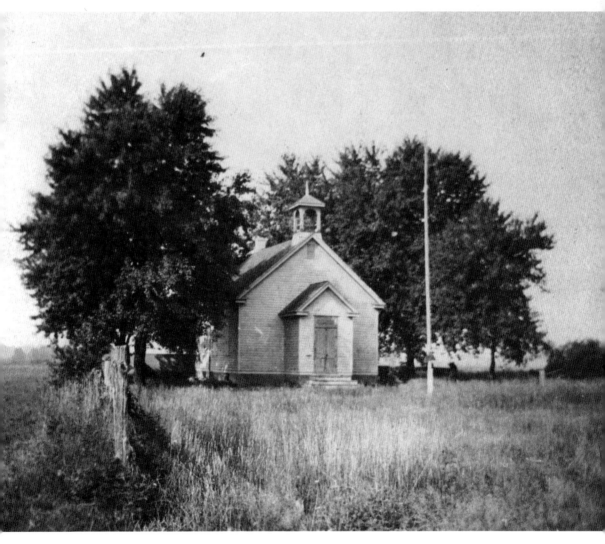

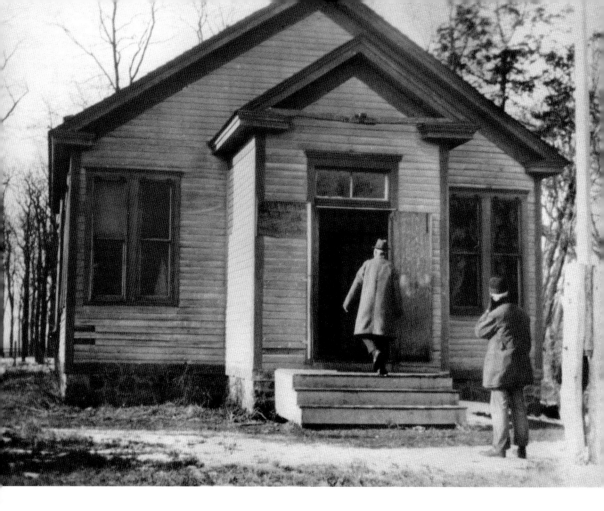

The Horner Hill School was located on Haddonfield-Berlin Road near the Downs Farm development. The school was in existence in 1877, when it was shown on an atlas to be tucked on a small corner of Montgomery Stafford's 36-acre farm. The school closed in 1925 when the Wesley R. Stafford School opened on Haddonfield-Berlin Road. A brick ranch-style house is now located on the site of the old school. The house was built when Margaret Downs—a member of the Thomas J. Downs family for whom the farm was named—sold the farm to developer Max Odlen in the late 1950s.

Delaware Township's school district was considered progressive when the former J. Heulings Coles School opened on Church Road in September 1927, even though the township remained predominantly rural. The school, which was the largest school in the township prior to 1950, closed in 1978 and is now operated as a private institution. Shopping centers now occupy the pasture on which cows once grazed.

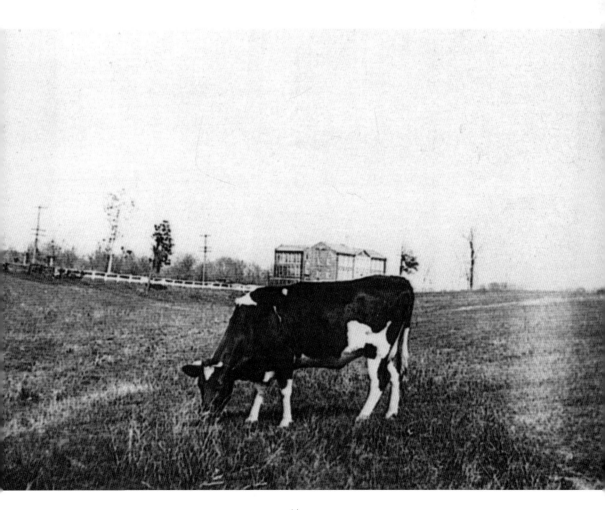

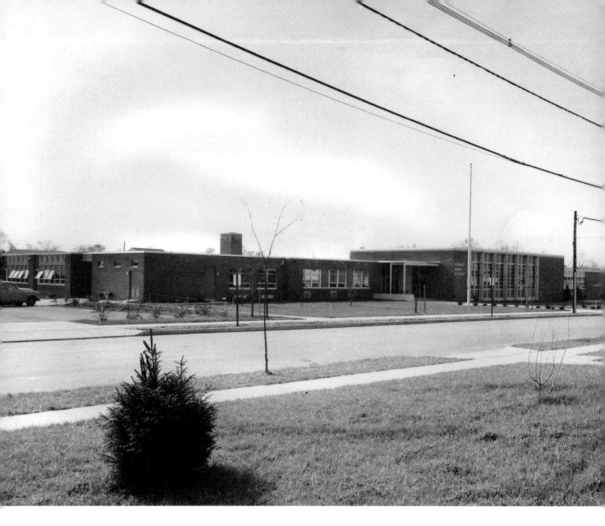

After the one-room schoolhouse of the 19th century and the brick multistory elementary schools of the early 20th century, Delaware Township school officials began constructing modern brick elementary schools. One such school was Horace Mann, an elementary school that opened in 1962 in the Downs Farm subdivision. The school continues to educate students in kindergarten through fifth grade.

Kingston Estates was the first large-scale development built in Delaware Township after World War II. Developer Harry Goodwin purchased land situated on Kings Highway between Moorestown and Haddonfield, which had been part of the 500-acre DeCou farm, and constructed ranch, split-level, and Colonial-style homes. In the view below, Chelten Parkway begins to take shape. The photograph on the right shows Chelten Parkway as it appeared in 2001.

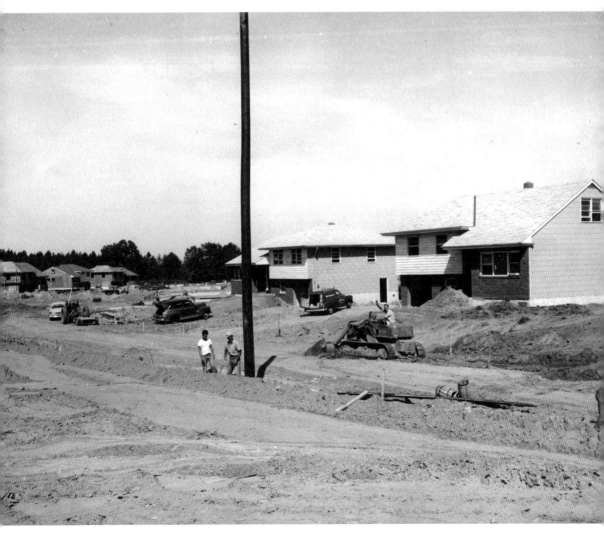

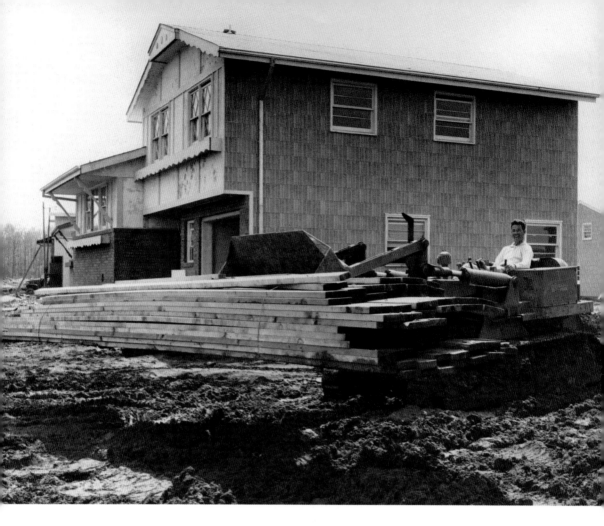

A construction worker on a forklift makes short work of the lumber used in the construction of the homes in Kingston Estates in the 1950s. The basics of home construction may be virtually unchanged in 50 years, but the prices are not. Most new homebuyers in Kingston Estates paid less than $25,000 for a house in the mid-1950s. Meanwhile, these homes under construction on Manor House Court in the Short Hills Farm subdivision were priced at more than $300,000 in 2001.

For years, DeCou's Market and Dairy Bar was a landmark at Kings Highway and Chapel Avenue. The DeCou family acquired 500 acres of farmland on both sides of Kings Highway in 1911 from the Ellisburg Circle to Chapel Avenue. Harry Goodwin bought the land east of Kings Highway, which had been a peach orchard, for $600 per acre in 1953 and built the Kingston Estates development. The farm market property is a shopping center today.

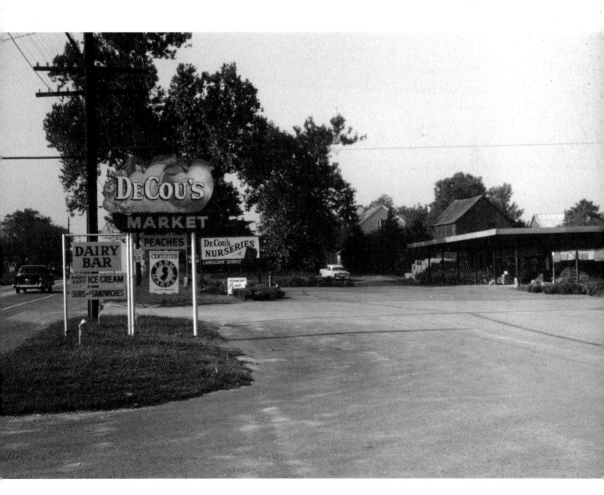

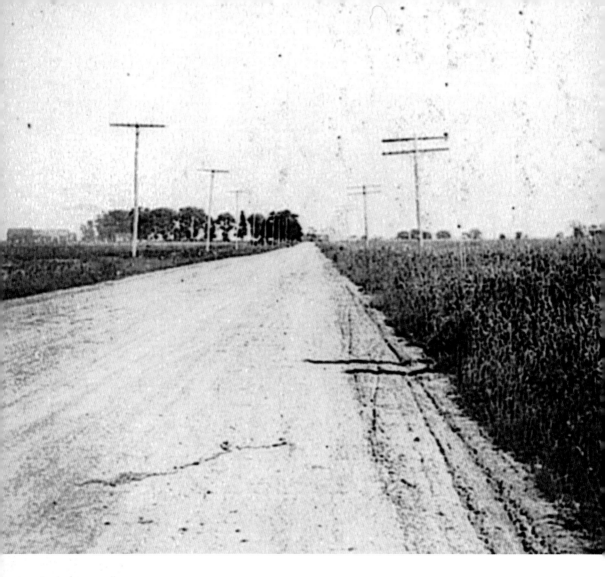

Like many of the roads in rural Delaware Township, Chapel Avenue was little more than a quaint dirt lane lined with cornfields when this photograph was taken in the 1920s. This section of the road, which is located between State Street and Route 38, is now one of the busiest roads in the township.

The Chapel Avenue bridge has been a landmark in the Woodland section of Delaware Township–Cherry Hill for generations. The bridge passes over railroad tracks, which New Jersey Transit uses for trains traveling between Philadelphia and Atlantic City.

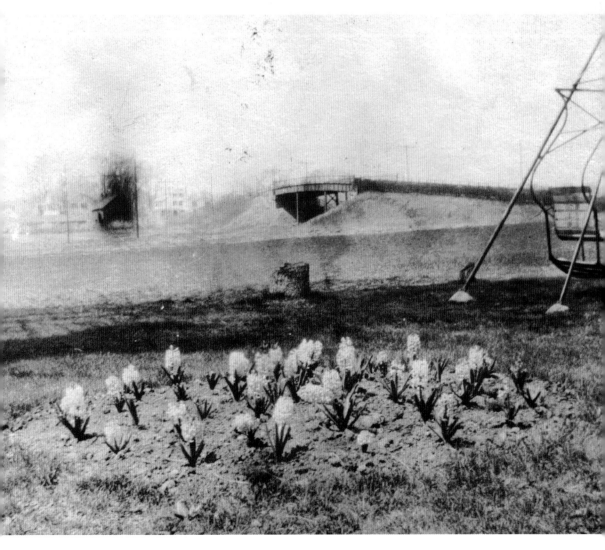

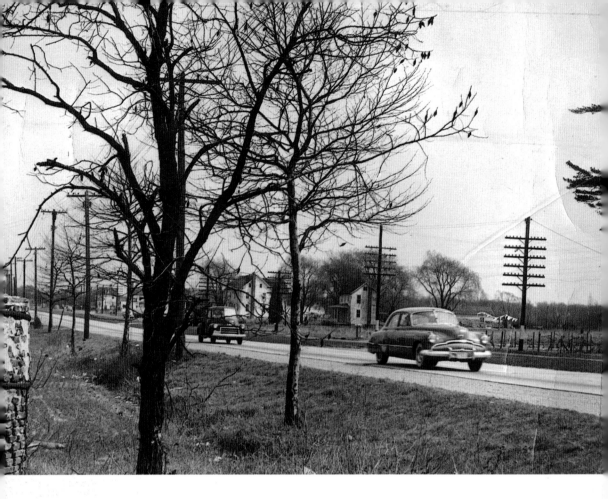

Marlton Pike (Route 70) was a rural highway when this photograph was taken in the late 1940s, before the New Jersey Turnpike divided the township. The same area, which now includes an intersection for Interstate 295, is shown today. (Courtesy Burlington County Historical Society.)

The photograph below shows Marlton Pike (Route 70) near Calvary Cemetery in the 1930s. At that time, Delaware Township was considered remote because of the concentration of the area's population in the city of Camden and other inner-ring suburbs, such as Pennsauken and Collingswood. Today, the area is the western gateway to Cherry Hill and has undergone revitalization. (Courtesy Camden County Historical Society.)

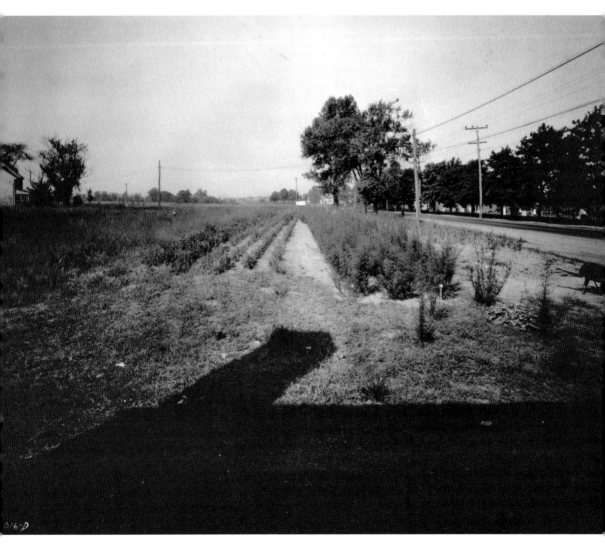

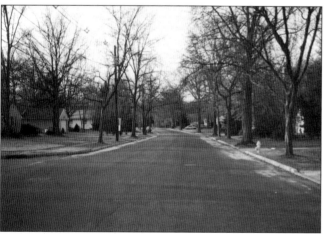

Barclay Lane is shown above in 1958 as Barclay Farm was being developed. Collingswood developer Bob Scarborough carved the massive development from farmland that was situated between Marlton Pike and Kresson Road.

As the centerpiece for his Barclay Farm development, builder Bob Scarborough chose to construct a covered bridge over the north branch of the Cooper River. The bridge, which was the first covered bridge built in New Jersey in more than 90 years, was dedicated on February 14, 1959.

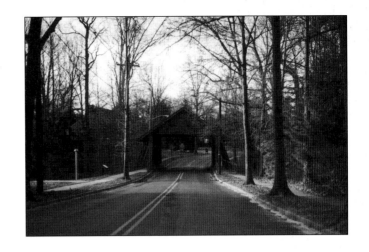

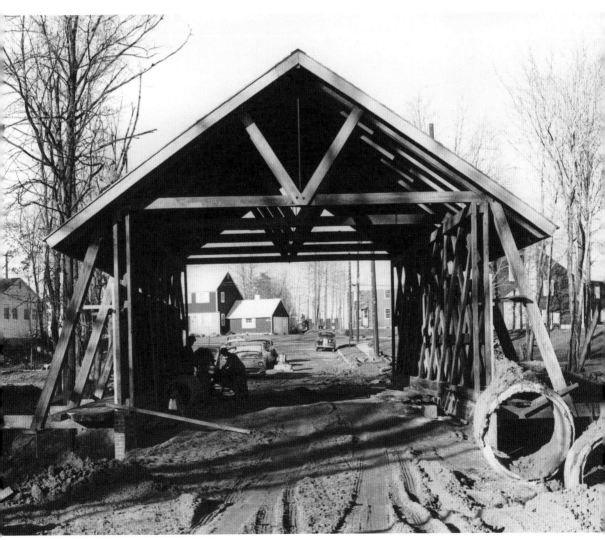

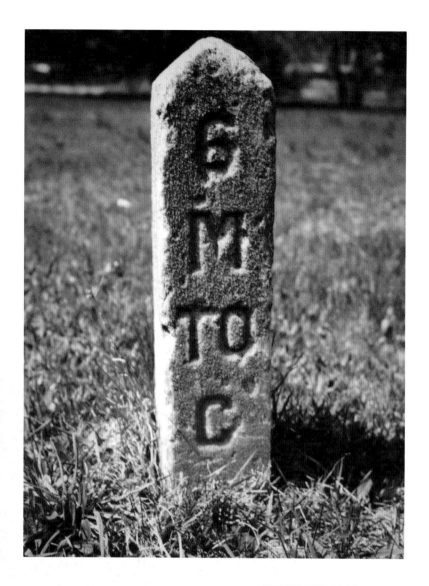

This stone milemarker was a common site along South Jersey roads in Colonial times. The marker, which means that it is six miles to Camden, stood in the vicinity of the Saltzman House on Marlton Pike. More contemporary signs have replaced markers such as this one.

Since Cherry Hill has no downtown, the court of the Cherry Hill Mall has served that function for nearly 40 years. Thousands of children visited Santa Claus there, and shoppers enjoyed concerts and shows. Cherry Hill High School held its junior prom in the mall court in 1962. The Cherry Hill Mall was constructed in 1961 by the Rouse Company and drew busloads of curious shoppers from up and down the East Coast. It remains the anchor of a vibrant shopping corridor that extends along Route 38 from Cherry Hill to Mount Laurel.

*Chapter 2*

# BUSINESS
# AND
# COMMERCE

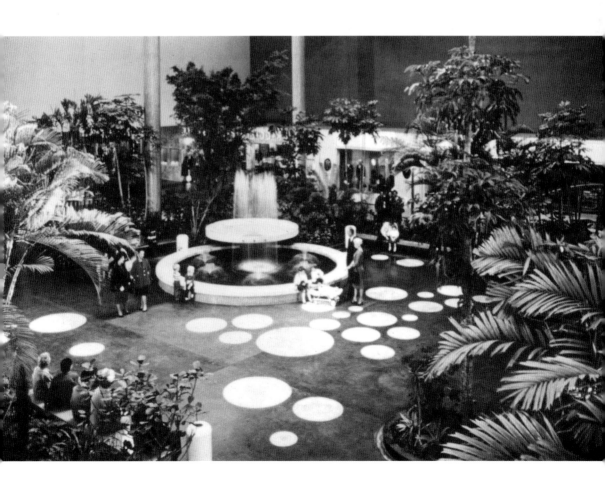

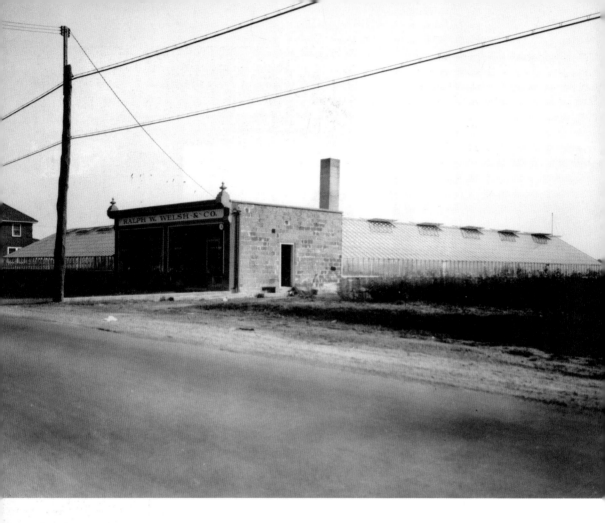

This greenhouse was just one of a handful of businesses that existed along Marlton Pike (Route 70) in the 1920s and 1930s. Although this business was located near the township's border with Pennsauken, the area remained relatively rural until the 1950s, when the exodus of people from Camden to the suburbs accelerated. (Courtesy Camden County Historical Society.)

The Swiderski brothers, Stan and Carl, operated this barbershop on Chapel Avenue for many years. Stan Swiderski, now in his 80s, continues cutting hair there.

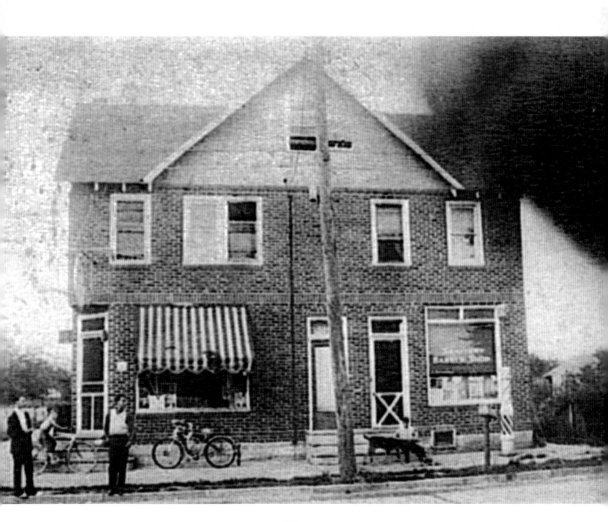

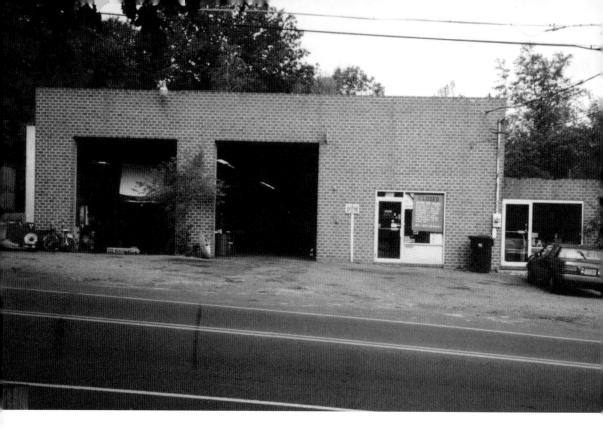

Mike's Out of the Way garage was located for years along Springdale Road between Evesham and Kresson Roads. Owner Walter "Mike" Michaleski earned his living by servicing farm equipment for the farmers who lived nearby. As suburbia encroached, Michaleski switched to repairing vehicles. The garage was demolished in 2000; a new housing development, Springdale Crossing, is shown being built in its place.

The Pennsylvania Railroad Seashore Line operated a line that ran through a small part of Delaware Township en route to the Jersey Shore in the early 20th century. In February 1969, the Delaware River Port Authority opened the PATCO High Speed Line, a 14.2-mile line between Philadelphia and Lindenwold that used the same path as the Seashore Line. These photographs were taken between the Haddonfield and Woodcrest stations. (Courtesy Delaware River Port Authority.)

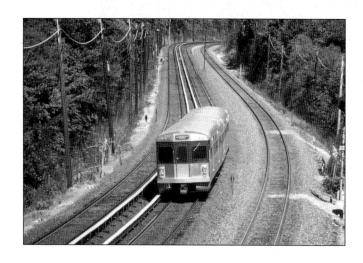

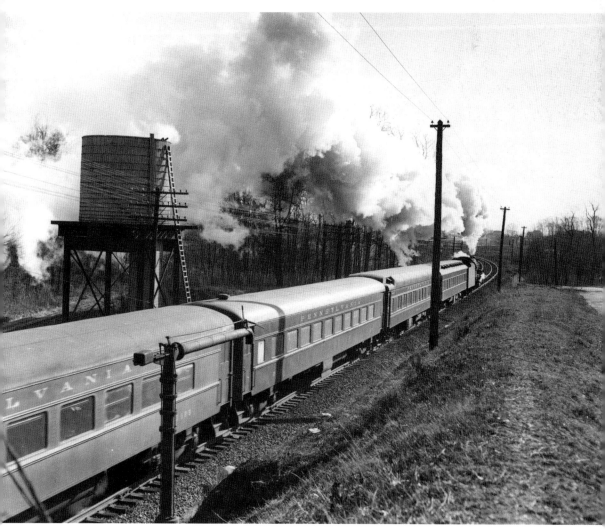

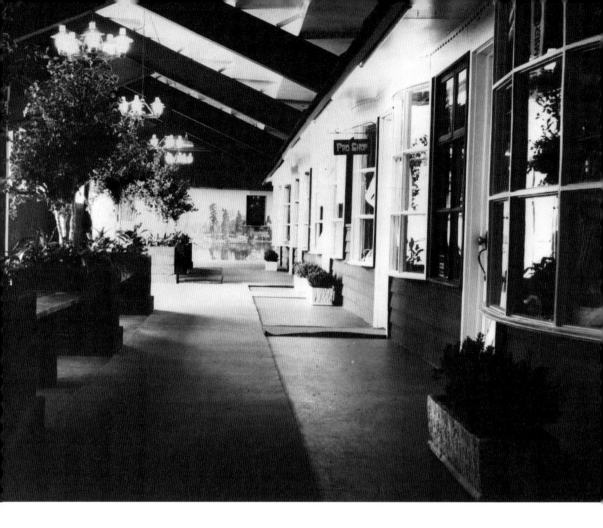

The Ice House, later known as the Cherry Hill Arena and the Centrum, opened in 1959 at Brace and Haddonfield-Berlin Roads. It was home of the Minor League New Jersey Devils ice hockey team and hosted closed-circuit television boxing and live events. It is now the site of a shopping center.

Before the Cherry Hill Mall and strip shopping centers were built, Delaware Township residents did most of their shopping along Kings Highway in Haddonfield or on Main Street in Moorestown. The shopping district continues to thrive despite competition from shopping centers and chain stores.

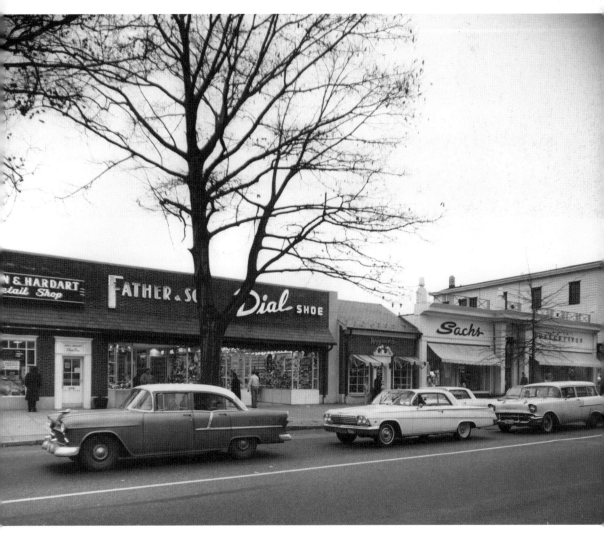

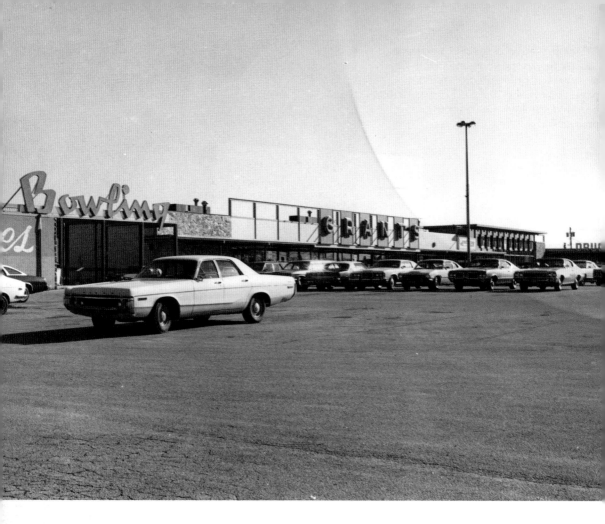

Morris Sarshik, the developer of the Woodcrest housing development, built the Woodcrest Shopping Center in 1960. For six years prior to the opening of the shopping center, Sarshik operated a community bus service to Haddonfield for Woodcrest residents who needed to do their shopping.

The Ellisburg Shopping Center was
one of several shopping plazas built
to cater to the burgeoning suburban
population in the 1960s. The center has
been redeveloped and continues to
prosper today.

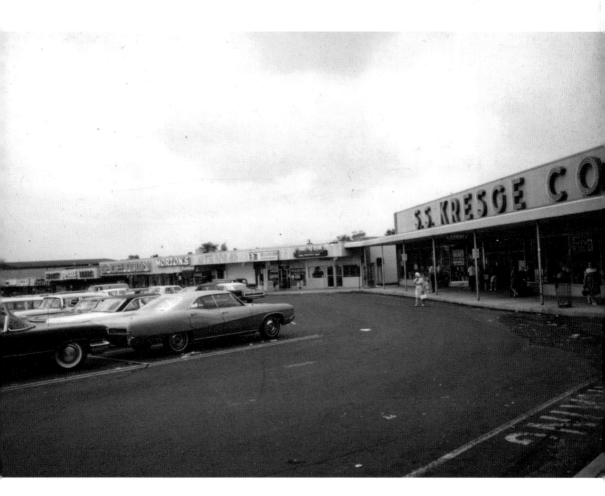

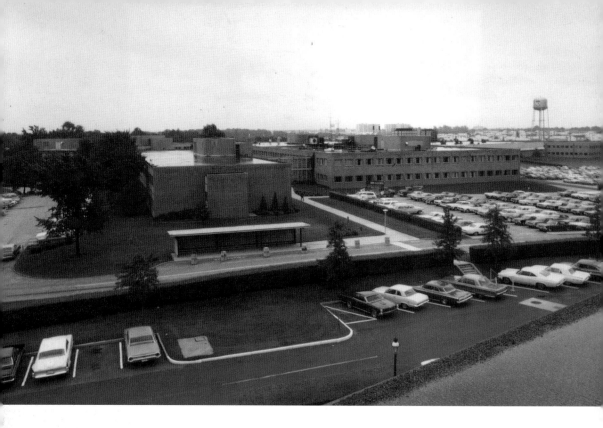

The RCA complex was built along Route 38 adjacent to the Cherry Hill Inn in the 1950s. The land on which RCA, the inn, the Cherry Hill Mall, and the Cherry Hill Estates neighborhood were built was part of the Stiles farm. The RCA property site is now the location of the Hillview Shopping Center.

This Little League team, sponsored by Airport Pontiac—a now defunct dealership on Admiral Wilson Boulevard in Camden—was among the first to organize in Delaware Township. In 1955, Morrisville, Pennsylvania, defeated Delaware Township 4-3 in seven innings in the first extra-inning Little League World Series championship game. A player for the New Jersey team was Billy Hunter, who would go on to play professional football and become executive director of the NBA Players Association. In 1956, Fred Shapiro of Delaware Township pitched the first Little League World Series perfect game.

*Chapter 3*

# NIGHTLIFE

# AND

# RECREATION

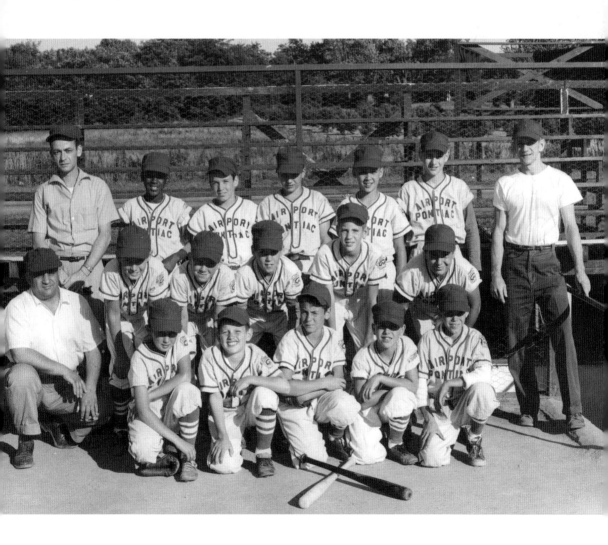

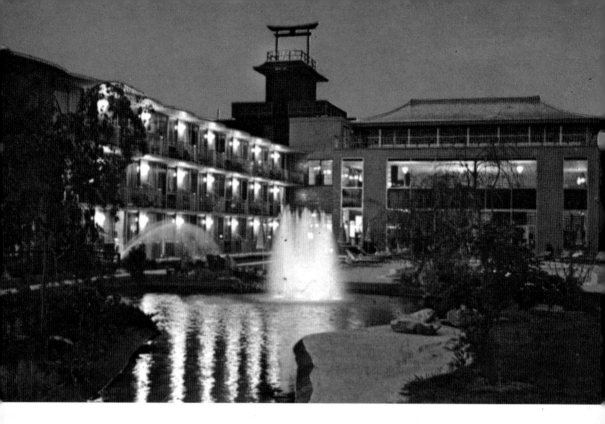

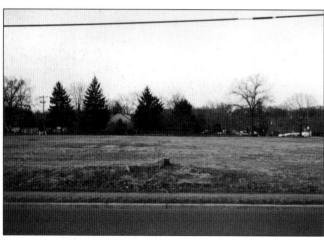

The Ricksshaw Inn stood on Marlton Pike (Route 70) across from Garden State Park and was a popular gathering spot. Built in 1964, the 164-room hotel featured a 22-carat gold-plated roof, Oriental motif, and winding staircase overlooking the lobby. The Rickshaw was closed by an electrical fire in 1988 and was torn down in 1999.

The Hawaiian Cottage stood along Route 38 for more than 40 years before it was destroyed by fire on July 1, 1978. It is pictured below before its distinctive yellow pineapple was added. The site is now home to the Olive Garden restaurant, which was rebuilt in 2000 as part of a major renovation project undertaken by its parent company.

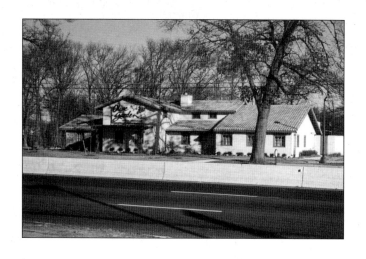

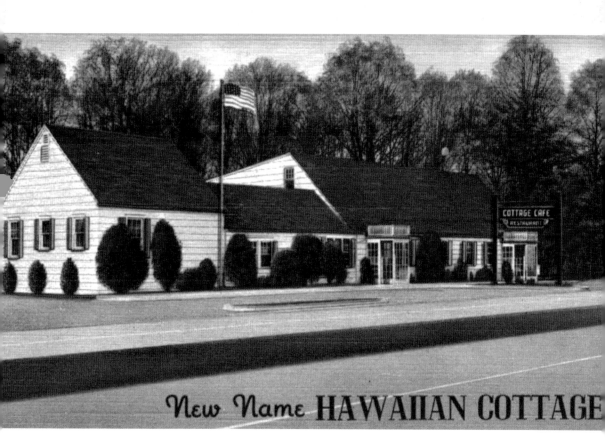

New Name HAWAIIAN COTTAGE

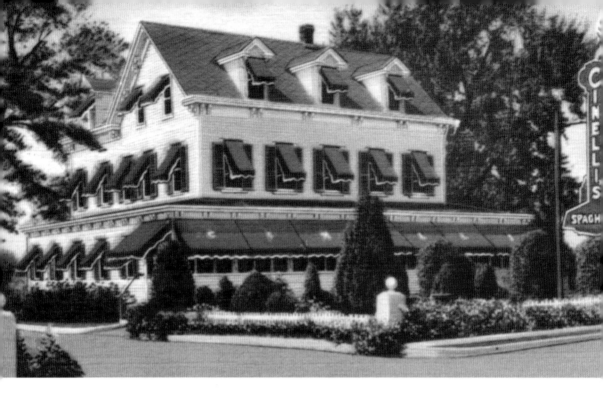

Cinelli's Country House was one of the first restaurants in Delaware Township, opening in a converted farmhouse in 1934 on Haddonfield Road near Route 38. The restaurant, which had its roots in Camden, was demolished in 1988 to make room for an office building, Libertyview.

The Rustic Tavern on Marlton Pike (Route 70) was another popular restaurant and gathering spot in the 1960s. After a succession of restaurants at the location through the 1990s, the location remained vacant in 2001.

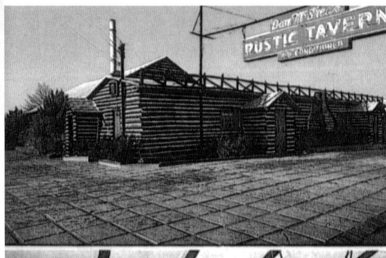

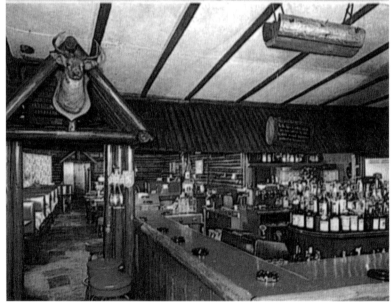

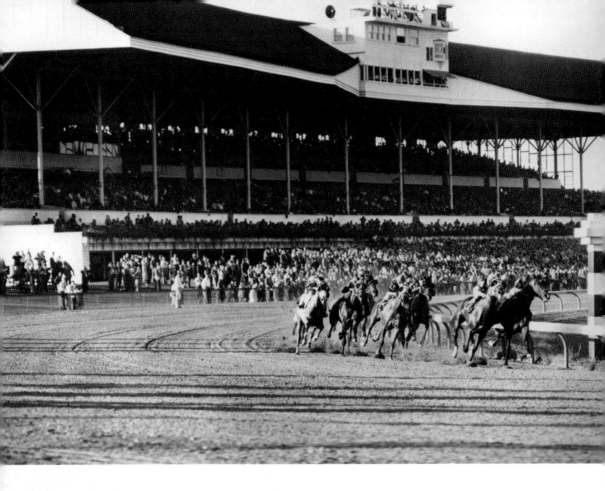

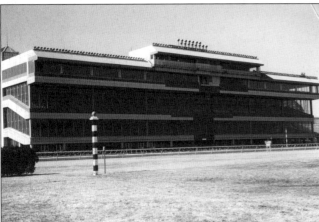

Horse racing was among the nation's most popular pastimes when this photograph was taken just after the opening of Garden State Park at Marlton Pike (Route 70) and Haddonfield Road in 1942. The track, which was built by Vineland entrepreneur Eugene Mori, was the centerpiece that spawned the development of Delaware Township into an entertainment, dining, and shopping destination. The grandstand was destroyed by fire on April 14, 1977, and was rebuilt in 1985, but the track never regained its grandeur. The track's last thoroughbred meet was held from April 13 to May 3, 2001. The track was scheduled to be razed in late 2001 to be replaced by a multiuse development.

M ori opened the Cherry Hill Inn at Route 38 and Haddonfield Road in October 1954 on the site of Civil War veteran Abraham Browning's 134-acre farm known as Cherry Hill. Browning built his home on the site in 1875 and purportedly named it for cherry trees on the property. The hotel abruptly closed in 1992 and was destroyed by fire in April 1996. The site is now occupied by a 24-screen movie theater.

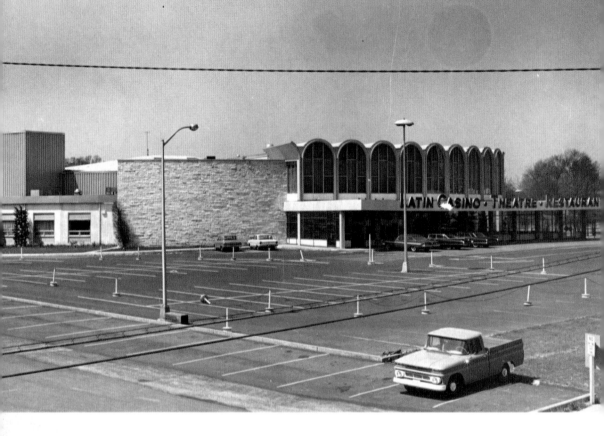

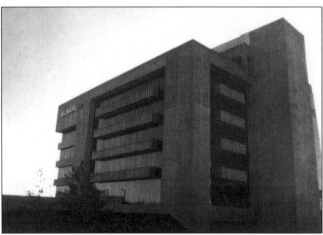

The Latin Casino was started in Philadelphia in 1950 and relocated to Marlton Pike (Route 70), Delaware Township, in October 1960, fast attracting many of the top performers of the day. It closed in June 1978 because of rising operating costs and competition from the casinos in Atlantic City. It reopened as a discotheque called Emerald City before closing permanently in 1982. The property is now the site of Subaru of America's national headquarters.

When many people think of Cherry Hill, they think of Ponzio's, which had stood on Marlton Pike (Route 70) near the former Race Track Circle for many years. The restaurant continues to thrive in the same location today. It is well regarded as a gathering spot where business deals are forged and family milestones are celebrated.

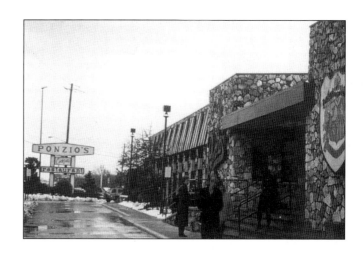

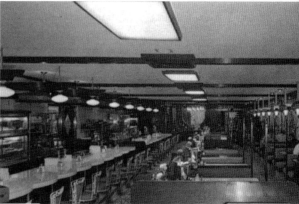

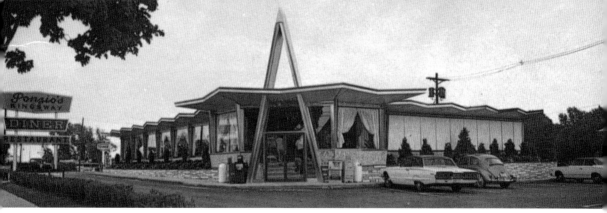

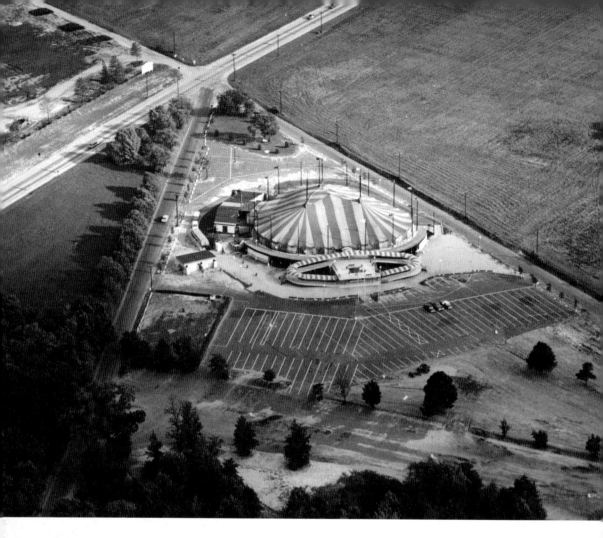

The Camden County Music Fair was located at Brace and Borton Mill Roads and featured nationally known entertainers from the time it opened in June 1956. Lagging attendance forced the closure of the music fair in 1969. It is now the site of the Challenge Grove Park.

The Cowtail Bar at Holly Ravine Farm was one of the most popular family destinations in Cherry Hill. Located at the corner of Evesham and Springdale Roads, the Cowtail Bar was opened by Holly Ravine Farm Dairies owner John Gilmour to market surplus. Gilmour, who would later become Cherry Hill's first mayor, made his own ice cream and had a small zoo on the grounds. Part of the property was sold in the late 1980s, and the Holly Ravine Shopping Center was built. Gilmour's widow, Eva Gilmour, continued to live on the grounds of the old farm in 2001.

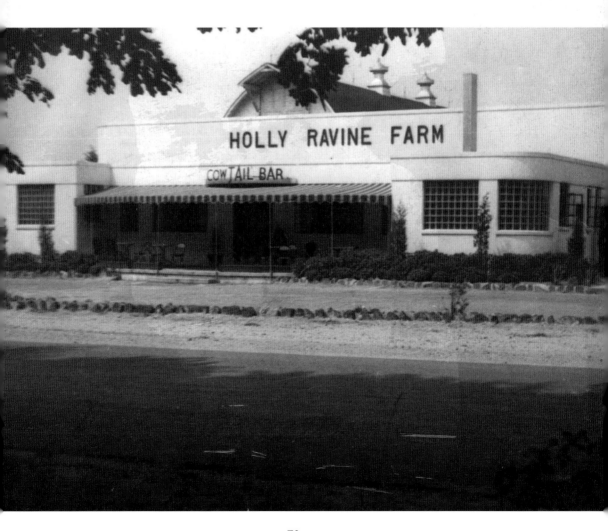

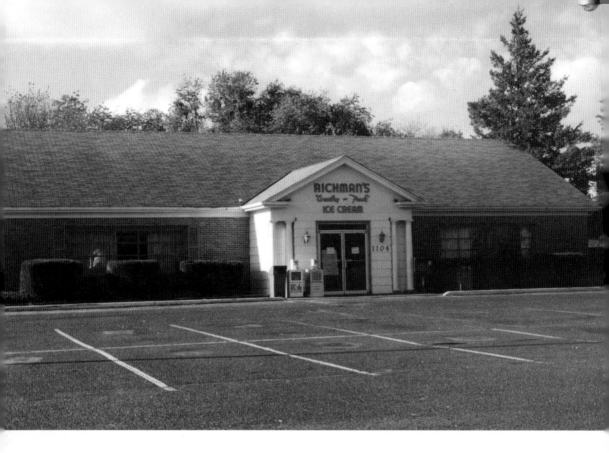

Richman's was a favorite family destination on Kings Highway, next to the Cherry Hill Library, for many years until it was demolished in 1999.

S tudents who attended the Wesley R. Stafford School in 1925 pose in front of the school on Haddonfield-Berlin Road. The school (pictured in the top frame, with a Model T parked next to it) was one of several brick schoolhouses built in the 1920s to replace the antiquated one-room schoolhouses prevalent during the 19th century. The Stafford School closed in 1978 due to decreasing enrollment and is now occupied by a private school.

*Chapter 4*

# AROUND TOWN

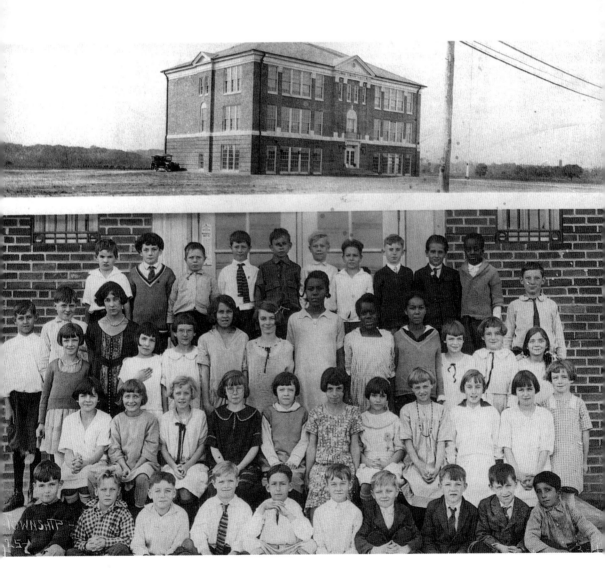

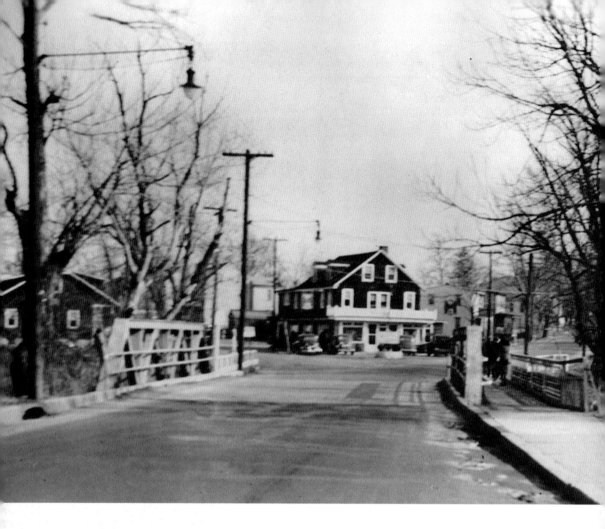

William Bates's home at the junction of Kresson and Haddonfield-Berlin Roads was transformed into the Blazing Rag Tavern, which operated from 1850 to 1900. Among the events hosted at the Blazing Rag was cockfighting, an event that attracted spectators from as far away as Philadelphia. The bar would also be known as the Hess Tavern before turning into its present incarnation as Kress' Liquors.

Below, several men relax at the bar at the Hess Tavern sometime in the 1930s. The menu posted above the bar features such delicacies as pigs' feet. In the photograph on the right, Martin Zoblin tends the bar behind Kress' Liquors. Zoblin was the longtime owner of the store before selling his share of the business to partner Mario Delmonte, who plans to transform the bar in the rear of the liquor store into an area for fine wines.

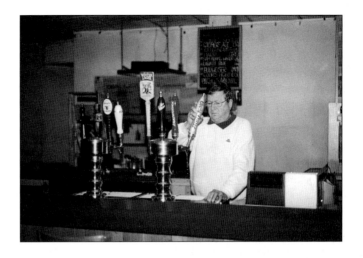

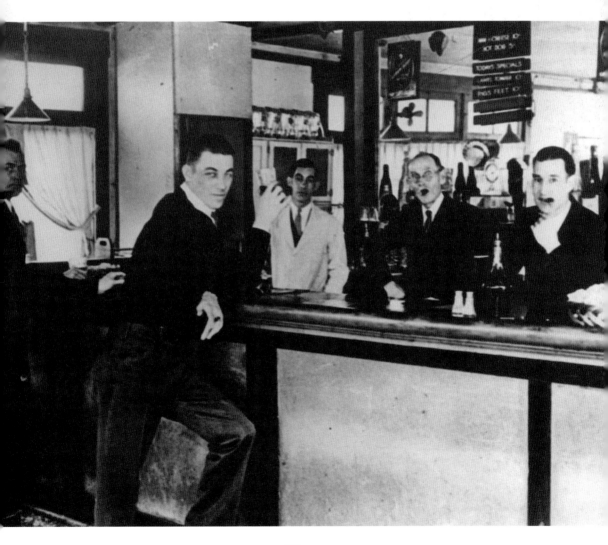

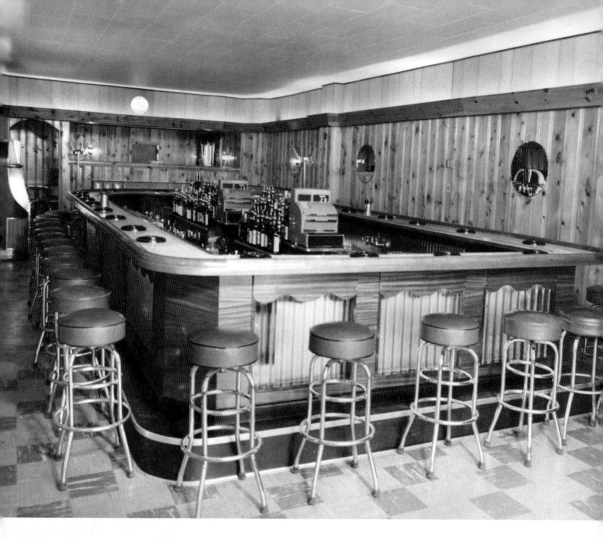

Lena's has been a fixture on Chapel Avenue for more than 50 years. Named for and operated by Lena O'Brien, the neighborhood tavern was heavily damaged by fire in 1950 but was reopened shortly thereafter. It continues to be a popular gathering spot.

Lena O'Brien's son John poses below in front of the barn that stood next to his mother's tavern. The photograph on the right shows John standing in the same spot in 2001.

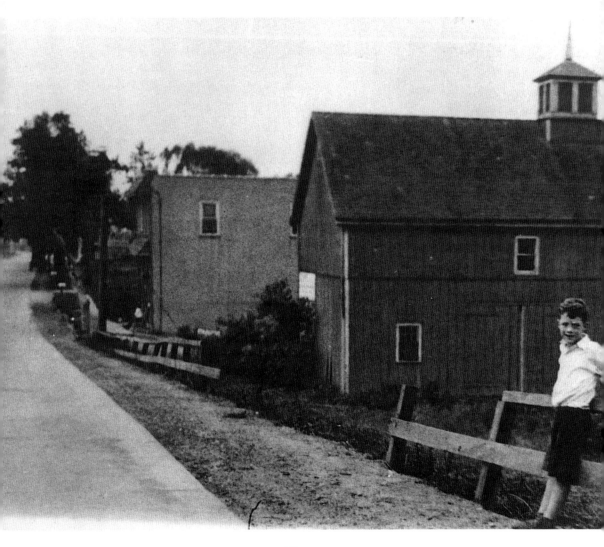

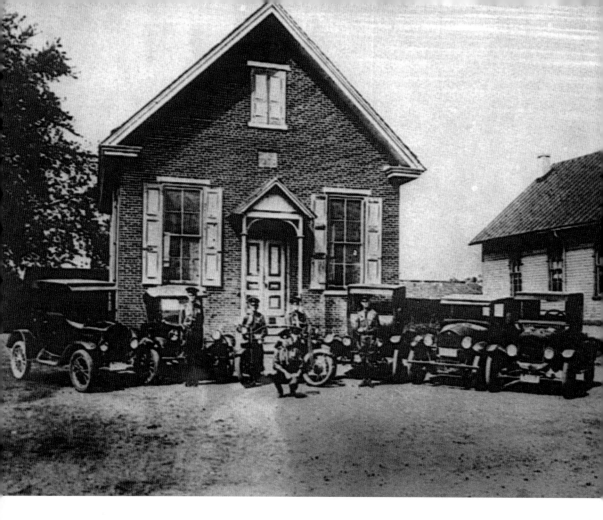

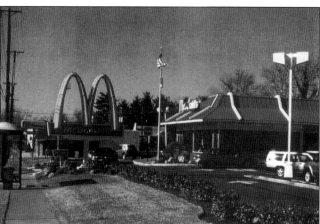

The old town hall served numerous functions in the early days of Delaware Township when it was located on Marlton Pike (Route 70) near the old Ellisburg Circle. A new township building was constructed on Mercer Street in the 1960s, and the old town hall was razed. It is now the site of a McDonald's restaurant.

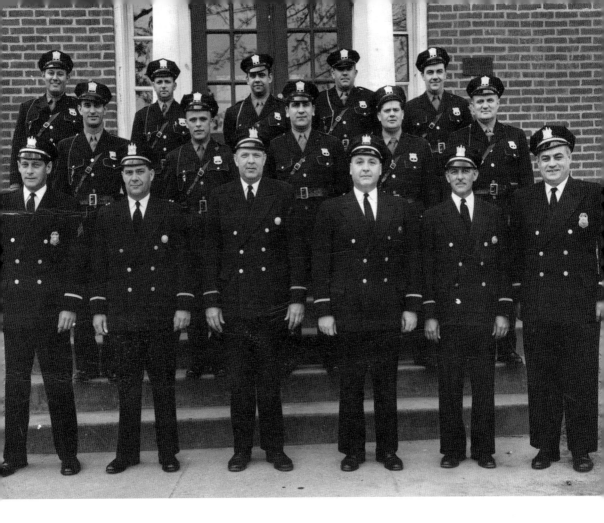

The Delaware Township Police Department employed a fraction of the more than 127 sworn officers it has today when this photograph was taken in 1953. The police department was organized on May 1, 1924, when John S. Branin was appointed the first patrolman. He served in that capacity until the fall of 1924, when he was given the rank of chief and five special officers were named to serve with him.

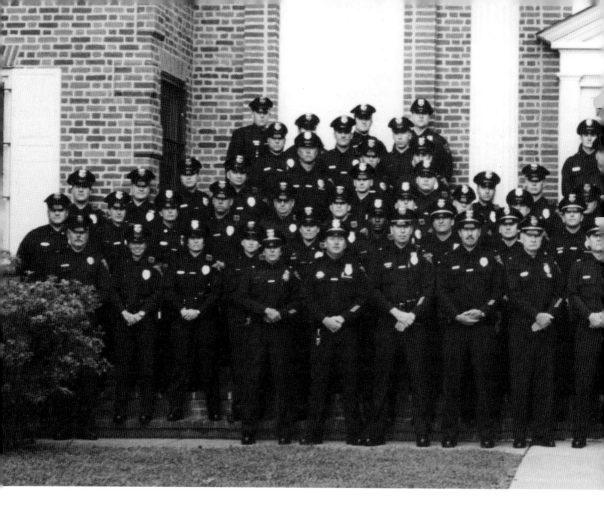

Members of the Cherry Hill Police Department pose for a photograph in 2001. The department has

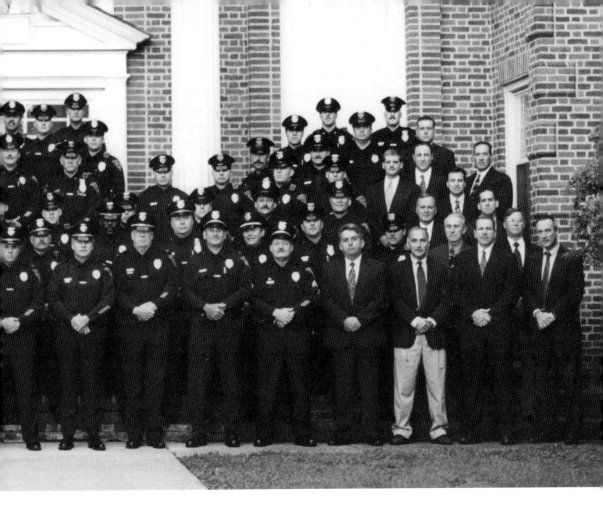

several divisions, including internal affairs, investigative, and traffic safety.

The Church Road Fire Company was one of seven fire companies organized between 1914 and 1948 in Delaware Township. The fire company and the Church Road Civic Association remain vital components of the community today. The township's first fire company, Woodcrest, was organized in 1914. The last one was Deer Park, founded in 1948. In addition to fighting fires, the fire companies also

met a social need in the community through fundraising activities and hosting meetings, socials, and receptions. The six fire companies became one full-fledged fire department on January 1, 1994. Today, the Cherry Hill Fire Department operates predominantly with a career staff but also supplements its ranks with volunteers.

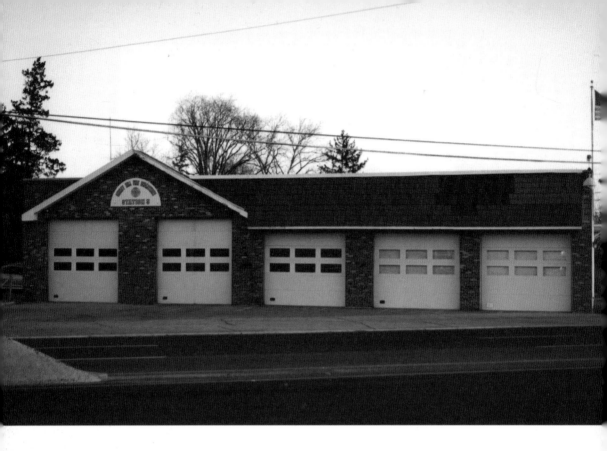

The present Church Road firehouse stands on the same site as the original building.

Below, several members of the Erlton Fire Company stand in front of a piece of apparatus in the 1940s. To the right, five present members of the Cherry Hill Fire Department pose with an engine truck outside the fire station on Marlkress Road. They are, from left to right, Art West, Bob MacDermott, Frankie LaMarra, and John Gibson.

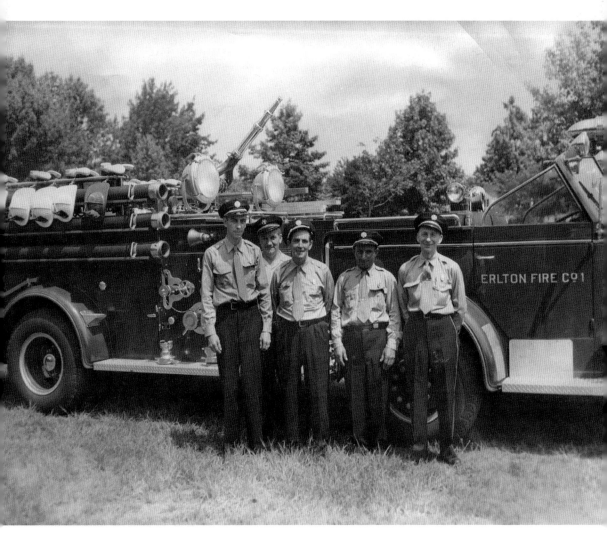

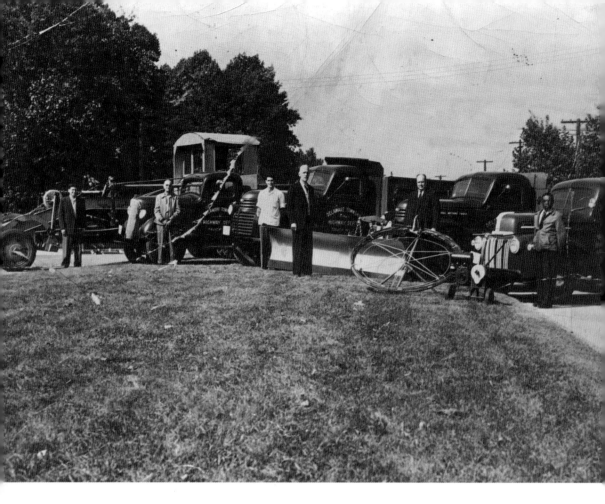

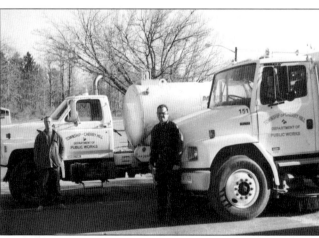

From the township's early days, residents have counted on the road crew and public works department to maintain roads and parks. The department has grown as the township has grown in population. Shown on the left are employee Bill Ward and highway division head Frank Bryson.

The Cherry Hill Baptist Church began in 1959 and eventually built this church off Browning Lane behind the Woodcrest Shopping Center. A new church was built later as the congregation continued to grow. The congregation was undertaking a building expansion program in 2001 with renovations to its Koinonia building.

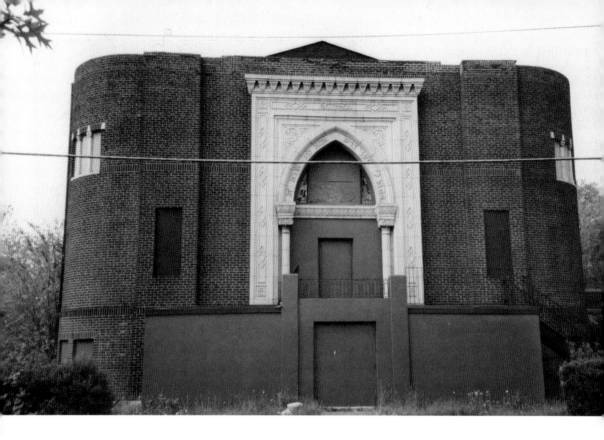

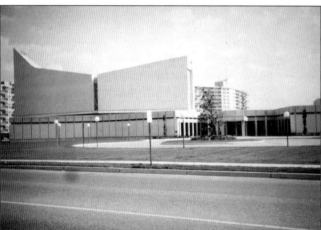

Congregation Beth El Synagogue was founded in 1920 in the Parkside section of Camden. The congregation prospered in Camden for decades but moved to its current location on Chapel Avenue in 1968 as members moved out of the city into Cherry Hill. Beth El is one of five synagogues in Cherry Hill, which also has been home to the Jewish Community Center since the 1950s.

The first St. Mary's Roman Catholic church was built in March 1938 on Marlton Pike (Route 70) near what is now the entrance ramp for Interstate 295. It had been a mission of Christ the King and later Queen of Heaven before it was officially designated a parish in 1961. Increasing traffic along Marlton Pike forced the congregation to move to its present location on Springdale Road in 1962. There are six Catholic churches in Cherry Hill.

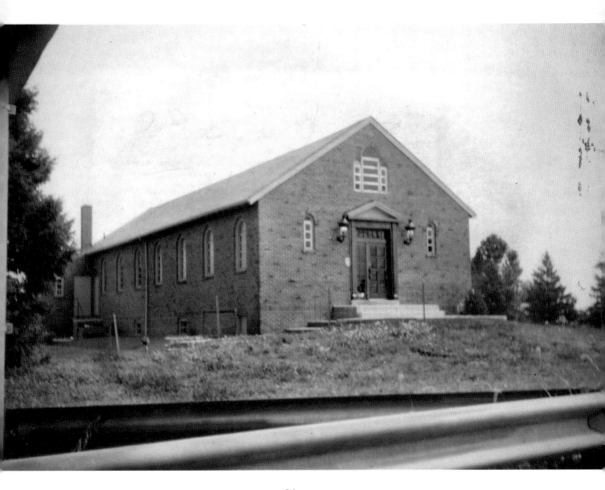

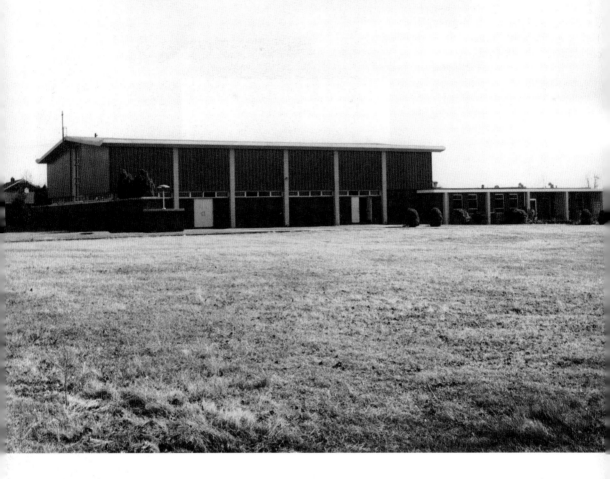

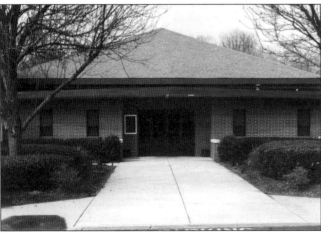

This was the original church building for St. Pius X Roman Catholic Church, which is still in use today as a parish hall. St. Pius X was founded on June 10, 1961, and was formed from Christ the King in Haddonfield. Mass was first celebrated at the Ice House at Brace and Haddonfield-Berlin Roads until the new building, which consisted of a church, offices, and a rectory, was constructed in 1963. The present church on Kresson Road was completed in 1979.

The Unitarian church was built along Kings Highway in the 1960s but was heavily damaged by fire in the 1990s. A new church was being constructed in 2001.

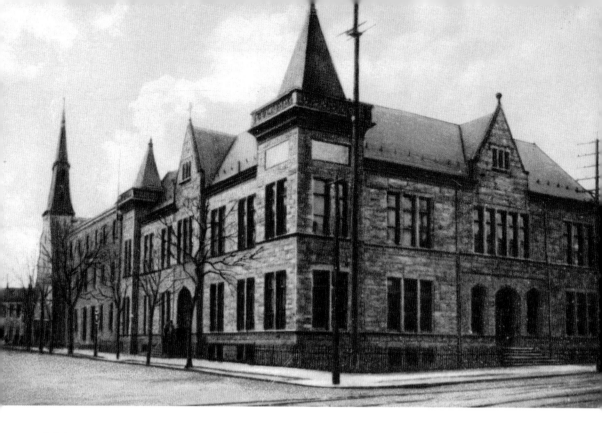

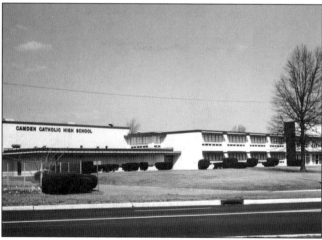

Camden Catholic High School was built in Camden in 1896 and was heavily damaged by fire on Easter night, April 17, 1960. The damaged buildings, the former Lyceum building, and the original St. Mary's Elementary School, contained an auditorium, library, and 18 classrooms. The present Camden Catholic High School opened in September 1962 on a 33-acre tract at Route 38 and Cuthbert Boulevard. (Courtesy Camden County Historical Society.)

The Cherry Hill Apartments were the first high-rise apartment complex in the township. They were built in 1957 on Route 38 between the RCA complex and the Cherry Hill Estates neighborhood. The apartments were considered upscale when they opened but fell into disrepair over the years. Township officials, who in 2001 were working to find a developer to redevelop the property, eventually closed the property.

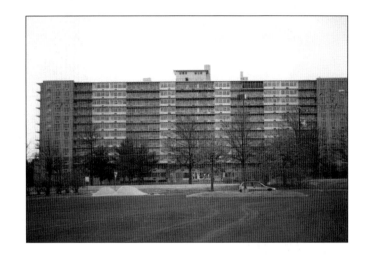

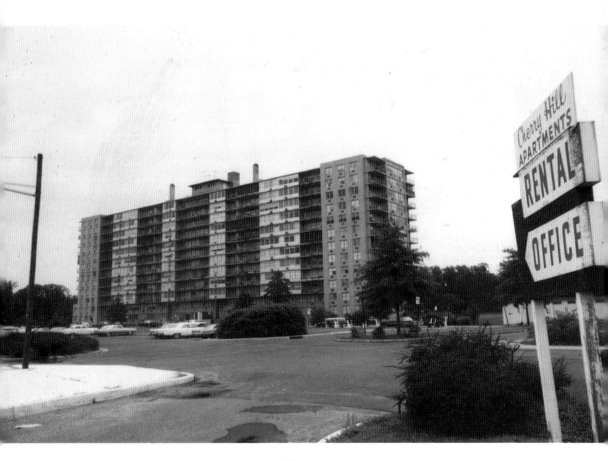

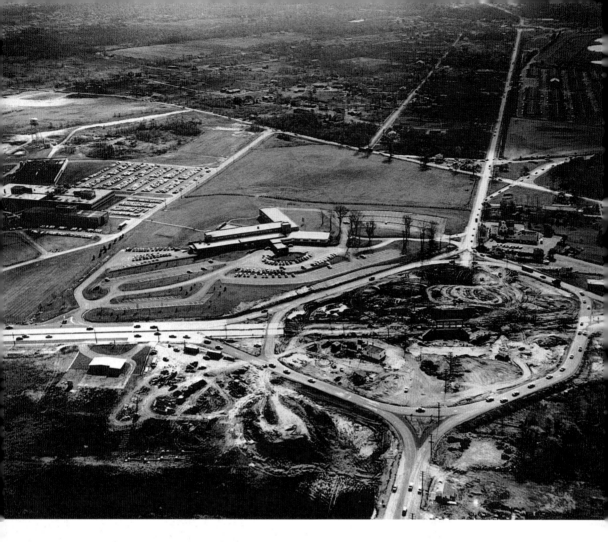

This is how the intersection of Route 38 and Haddonfield Road looked as the traffic circle, which existed since the 1930s, was being removed in the 1950s and how the area appears today. Route 38 is home to some of South Jersey's most successful businesses.